DATE DUE

the
artist
in the
market-
place

the artist in the market-place

making your living in the fine arts

by patricia frischer
and james adams

M. EVANS and Company, Inc., NEW YORK

Library of Congress Cataloging in Publication Data

Frischer, Patricia, 1948-
 The artist in the marketplace.

 1. Art—Marketing. I. Adams, James, 1951-
joint author. II. Title.
N8600.F74 706'.8 80-11273
ISBN 0-87131-315-4
ISBN 0-87131-323-5 pbk.

M. Evans and Company, Inc.
216 East 49 Street
New York, New York 10017

Design by Robert Bull

Manufactured in the United States of America

9 8 7 6 5 4 3 2 1

contents

introduction

Currently, there are some two hundred and ten thousand people graduated from universities in the United States each year with degrees in art.

Patricia was graduated from California College of Arts and Crafts and was faced immediately with the transition from the closeted and protected life of an art student to the open market of the competitive art world. While she was highly qualified as a sculptor, she had no idea how the art world operated and, indeed, had no idea how to begin selling her work.

Artists are graduated from universities and schools of fine art with certain particular talents: a knowledge of art history, detailed instruction in their particular chosen medium and technical and aesthetic training are among these. It is to be hoped that they have also begun to produce a serious line of work. They have not, however, been told what to do with their specialized talents once they leave school.

Often, these artists will opt for teaching jobs, give up their art as a serious, full-time occupation or strive for success on a personal level only. In many cases, such fundamental decisions are based not on an objective analysis of the

facts but on myths that are part of the artist's folklore. Part of this folklore states that involvement in selling your art means the sacrifice of integrity and subservience to the all-powerful demands of the commercial world.

For Patricia, the honors graduate with no knowledge of the art business, a period of travel in Europe led to her getting a job in an art gallery in London. While working there, she found herself adapting and assimilating information that was invaluable to her as an artist. Indeed, she eventually proved that an artist can adapt to the demands of the marketplace without undue compromise. Incidentally, while doing so, she rose to head the gallery.

After five years, she returned to the United States where she ran a university art gallery in California. By this time, she realized how great the need was among students and practicing artists for a working knowledge of the art market. She began to teach at the university, and her subsequent courses on art business were consistently oversubscribed.

Patricia has come to understand that though it does require the commitment of a small part of your time, involvement in selling your art does not necessarily mean the sacrifice of your integrity; it is possible to succeed within the current structure while continuing to produce art that you believe in. In fact, the greatest challenges to your integrity are more likely to occur *after* success has been achieved rather than during the struggle for recognition.

It is important to realize, however, that as in any other business, the art market is tough, ruthless and highly competitive. It has its own set of rules, and to compete effectively, a knowledge of these rules is essential. To begin to understand how this set of rules operates, perhaps it would be best to observe them at their most basic, and *base,* level.

On the most cynical level, the dealer (or businessman) creates a myth about the art in order to sell it. This is done by manipulating critics, entertaining collectors and museum trustees, creating a sense of exclusivity, applying pressure on

the artists in his stable to support each other, raising auction prices and giving works to critics, museum trustees and collectors in order to involve their efforts in a certain promotion.

A gallery takes on an unknown artist realizing that it will be paid a commission only on the sale of the artist's work. And since unknowns don't sell, the first job of the gallery is to get the artist some recognition.

(It is not generally realized, however, that the services of some art critics can be bought and that a favorable review can be the first stage in developing an artist's career. One art dealer we know purchased the services of a reviewer to write a critique of the work of some little-known artists due to appear in forthcoming shows. The dealer then printed the review in the show catalog, which was distributed to patrons of the gallery on opening night, as well as to the press. This created the image of unbiased support of the show by a known art critic.)

When a prospective collector arrives at the gallery, the dealer ushers him or her into the secluded back room of the elegantly furnished premises. He finds out what kind of work the collector is interested in, or helps him to develop a direction if he has none.

The gallery director might then fit the artist he is dealing with into the collector's specifications, using the critic's reviews to add an air of aesthetic integrity. The dealer will probably discourse at length on the investment value of a particular work, and, if he is good at his job, a sale may soon be made.

If the prospective buyer is a known collector, he may be on the board of trustees of a large museum, so pressure could be brought to bear for the artist's work to be shown at the museum. After all, once an investment is made it must be protected, and a museum show usually raises an artist's prices. Works by the artist may then be given or discounted to critics or museum directors, and vested interests are established.

When the artist's work comes up for sale privately or at

auction, it is worth the while of the gallery owner to see that the work changes hands for the current market price. Again, this helps protect everyone's investment. Allegedly the dealer does this for the artist, and that is why the gallery gets its commission.

Fortunately, life is not quite as bad as that. Most dealers are genuine art lovers and humane people who hardly have even enough money to support their interest. It should be remembered that it takes an average of five years before a dealer can expect to start selling the work of a new artist and ten years before the gallery can expect to make a profit. A gallery must balance the income from its established artists, or from selling antiques or master works, or from a framing operation perhaps, against losses accumulated from supporting its newer artists. Tax laws are advantageous for the first three or four years after the start of a gallery, and a large company or private benefactor might support a gallery until it has time to establish its reputation. But very few gallery owners get rich quick, for it takes time to build a list of collectors, attract an artist for a specific stable and then have a proven track record of success to really inspire confidence. The balance sheet of most galleries bears this out with hard red pencil in the early years.

The range of galleries and alternative spaces is so great that artists no longer have to commit themselves totally to the world of big business. Whatever your level of participation in marketing your art, though, some knowledge of the intricacies of the art business is essential, whether you are dealing with a small-town co-op or a large New York gallery.

These days, artists succeed because they know the "business" and work very hard, not only at creating their work but also at keeping tabs on their public relations, accounting and the other business-related enterprises that are essential to success. They understand the structure of the art market, and this understanding brings them a greater measure of control over their own destiny.

The following chapters cover various problems you are likely to encounter while selling your art. The information in this book is intended to give you the opportunity to shape your own life, rather than having it manipulated by others.

CHAPTER 1

triumphs
and pitfalls

This chapter examines the careers of three different artists. While the graduating student may have a lot of sympathy with Christine Holt, the examples of Wiley and Rothko can open up vistas for the already established artist. The examples are intended to provide a sense of situations you may find yourself in as your career develops. Subsequent chapters give more examples and provide more detailed solutions to these and many other problems.

Christine Holt has been working as an artist for five years since graduating from college. She believes in her work sufficiently to pursue her art, and has taken a succession of odd jobs to support herself. The work has rarely been shown, except to friends.

A multitude of work in different media has piled up all over the house. None of the work is signed or dated, and because pieces are hardly ever sold, there is no attempt at cataloging. The older works have suffered the effects of abuse and are scratched and often badly worn. The newer work, however, shows progress and is well looked after.

While Christine visits galleries on a regular basis and has

certain strong preferences, she has never made any effort to get accepted by a gallery, largely through fear of the unknown and a terror of rejection. Still, she feels she needs feedback on her art. She also knows she is at a plateau in her career and feels restless, wanting to progress in her art and her life. She wants someone besides friends and family to buy the work. She spends money on supplies and has invested an enormous amount of her time in her work.

Finally, dissatisfied with working in a vacuum, Christine gathers a selection of her work, piles it into the back of a borrowed truck and sets off for a tour of her favorite galleries. She hasn't called to make an appointment, she has no idea of the galleries' policies on seeing new artists' work and no artist who is already with the gallery has recommended her.

The story is the same in each gallery. On her entering the gallery laden down with work, everyone ignores her. The secretary eventually asks for a resume and a selection of slides, which Christine hasn't thought to prepare and bring. In most cases, one of the gallery directors appears, looks at the work, asks the prices (Christine has no idea what she should charge), pronounces that the work shows "promise" and patronizingly dismisses her with instructions to the secretary to clean up the mess.

Christine ends her venture into the world of art business frustrated, angry and humiliated. Swearing she has put herself in the position of a pin in a bowling alley for the last time, she resolves to never again attempt to sell her work.

The scenario could, of course, have been different. A well-organized portfolio, an appointment made in advance with each gallery, some understanding of what the gallery might be looking for in an artist and a degree of self-confidence would have worked to distinguish the aspiring artist from the everyday amateur and draw the gallery director's attention to her. A little background planning could have saved a great deal of embarrassment and upset. The entire venture could have

been a stimulant to the artist's creativity, not the depressant it was.

William Wiley's career has developed along fairly traditional grounds. His years of struggle and self-doubt were fairly brief. He knew at an early age that art was to be his career. After graduating from high school, he waited four years before starting on his art education at the San Francisco Art Institute. He received his BFA and MFA degrees there, the latter in 1962 after already achieving a "one-man show" at the San Francisco Museum of Modern Art in 1960. He was also included in a number of group shows, including the important "Young America" exhibition at the Whitney Museum of American Art.

He started teaching at the San Francisco Art Institute the very year he obtained his degree, and until recently has continued in that position. He also holds a number of guest positions at both East and West Coast art schools.

After a few exhibitions with the Staempfli Gallery in New York, Wiley has now generally associated himself with the Allan Frumkin Gallery (branches in New York and Chicago) and the Hansen Fuller Gallery in San Francisco. Both galleries hold a quantity of his work on consignment in case a prospective purchaser arrives unannounced at the gallery. Wiley himself decides his exhibition schedule in coordination with these galleries. He also decides which museum and university shows he will involve himself in and what commissions he will undertake. Wiley is well known nationally and is branching out internationally.

Such success, however, is not without its problems. For example, a recent commission for a mural from the city of Hayward, California, was taken on under an informal (supposedly simple) agreement that Wiley would be allowed the artistic freedom to produce whatever he felt would best suit the space. As it turned out, the city's decision to accept or

reject the work turned into fierce political infighting in City Hall, with Wiley himself forced to become deeply involved.

Wiley's philosophy of letting things happen was present in his 1976 Museum of Modern Art solo show in New York. To a seven-foot plywood heart hung on the wall were attached numerous ball-point pens, with instructions to the public to "Draw Your Heart Out." Despite some of the MOMA officials' fears that other areas of the museum might come under the same attack, in the end the piece was allowed in the show.

Wiley is prolific and varied, and many critics have made a reputation for themselves by trying to title his style. Thomas Albright from *ARTnews* calls him a "Bay Region Myth-maker." Hilton Kramer of the *New York Times* would have him be a "Dude Ranch Dadaist." Wiley cannot be pinned down, however, and it is perhaps his ability to change constantly, yet remain essentially Wiley, that has made him a survivor of the art business.

Wiley is articulate and thoughtful on the subject of selling his work and in his advice to other artists. He speaks best for himself.

The first comment here is an excerpt from the 1971 Brenda Richardson catalog for his solo show at University Art Museum, Berkeley, taken from her taped interviews.

I think there was a lot of [the] attitude in there about not showing until it was right. Ultimately I think that's a very sound idea, you are the artist, and you are the one who has to figure that out. When you feel right about it, the work can be shown. You just have to realize that you can have that much control over it. But then the idea came through a couple of times that the person who wanted to buy that painting was really trying to buy you, or buy what you represent, or your energy. I just kept thinking, nobody can really do that to you, and I just decided, I should take those risks, and if that possibility was in there,

I just might as well find it out sooner or later. It just seems that anybody has a right to it, on whatever level they can get it on. I mean, the idea that it was bad for somebody to buy your painting because it matched their couch. It doesn't matter. If you've got a good couch and a good painting, and it takes care of a chain of visual events that gets it on for you, what's wrong with that?

I think art should be more and more amoral, a realm of exploration. Especially in school, if you could just get that idea across to people, it just means a whole threshold of getting into art, or the aesthetic experience, or awareness. Just give people a chance to go into it and really flesh out a lot of things and feel themselves in it, without having to set up a commitment to it in any way—to trust them enough to believe their commitment will grow out of their relationship to it.

This second statement was written by Mr. Wiley in May 1979 to be posted at a student show juried by him at Humboldt State University in Arcata, California.

Art and artists have a long history of survival—regardless of what supposed-critics-experts-famous artists might choose to say or do—accept or reject—on a particular day.

I don't think it would be harmful to look at being accepted or rejected from a show with equal amounts of skepticism.

One would hope the artist knows in their heart the worth of the work—the play—the effort.

That's the connection that matters. That's the jury that really counts. Anyone who loves making art won't be put off for long one way or the other.

A highly literate man, Wiley remains remarkably naive about the workings of the business world. He wants nothing

more than to be able to do his work, in isolation, and without the interference of such mundane matters as money, the cost of living and the IRS. Any encroachment on that ideal is treated as an attack on his life style.

Although his needs may be few, the demands that success brings are great. After more than twenty years as an artist, Wiley is having to come to terms with reality. Accountants, incorporation, agents and contracts all loom large. Wiley has never had a contract with the galleries representing him in the United States. His current rise in stature is forcing him to legitimize relationships that were previously informal.

Wiley is now in a strong position to make contracts that will be supportive of his own particular philosophy. However, he will need to find specific knowledge and expertise about contracts with galleries if he is to produce a workable business and artistic relationship. More and more he may find himself in the sort of situation he was in at Hayward and the Museum of Modern Art. A private agent may be better able to look after his interests and allow him the uninterrupted opportunity to concentrate on his art.

Mark Rothko did not have the relatively easy access to an art career that William Wiley did. Having briefly attended the Art Students League of New York at the age of twenty-five, he then spent the next twenty-five years committed to painting, but employed as a teacher, a profession he disliked.

In 1945, when New York was turned upside down by the new abstract expressionism, Rothko had a small reputation as a surrealist painter and was shown by Peggy Guggenheim. By late in that decade, he had changed his style to the new, more radical and idealistic expressionism and was included in the forefront of the movement along with Franz Kline, Willem de Kooning and Clyfford Still. His paintings were different and his life's intent was changing. He felt free of the necessity for security, free from the known and, most important, temporarily free from the need for success.

Success, however, is exactly what followed. In 1954, he was snapped up by the Sidney Janis Gallery. His price range leaped from the hundreds to the thousands. He was described in *Fortune* magazine as investment material at a time when art was being catapulted into an appreciating commodity.

It was not until the sixties that Rothko was able to indulge in his new-found wealth. He bought a brownstone house. He entertained and was entertained, something that put a strain on his marriage.

Throughout his career, Rothko had had very specific ideas about his work and how it should be shown. This led to fits of artistic pique when his work was not shown in natural light or in isolation from any other work of art. His wishes, of course, could not always be accommodated in the often limited space of the gallery or museum.

Not all the problems flowed from Rothko. A mural he thought was commissioned for a communal meeting hall was actually destined for an expensive New York restaurant. A communal hall fit in with Rothko's socialist ideals, but a smart restaurant was quite another matter. After considerable negotiation, the mural was eventually settled in the Tate Gallery where it is now displayed as Rothko intended.

Rothko was unprepared for the tremendous flow of cash brought about by his success. He mistrusted and finally broke off his arrangements with the Sidney Janis Gallery and began to arrange his own sales, although he often refused to finalize agreements. He was highly suspicious of the IRS and begrudged any tax payments, producing a reluctance to fulfill sales contracts. He also liked to hold on to paintings, selling them only after the price had risen. Rothko, in fact, ended up leaving seven hundred ninety-eight works in his estate.

Rothko relied heavily on his accountant, Bernard Reis, to write his will, set up a trust fund for his children, prepare his estate and average his income over the years in order to minimize tax payments. Mr. Reis was also one of the directors

of Marlborough Fine Arts. (Details of the estate manipulation are covered in Chapter 10.)

In 1968, Rothko had a heart attack. He was declared in satisfactory condition by his doctors, but only a few days later committed suicide. The exact reasons for his death have never been discovered. The circumstantial evidence of his life leads one to believe he could never justify the creation of a new freedom in his work with the creation of a commercial commodity on canvas. He never really knew whether people wanted his paintings or the money they could be exchanged for on the open market.

Rothko's lack of preparation for success and his inability to cope with it when it happened were a constant source of unhappiness throughout the later days of his career. The stream of irrational business decisions allied with poor advice undoubtedly contributed to his mental instability. In choosing Bernard Reis—his personal accountant and a director of Marlborough Art Galleries—and Marlborough themselves as his confidants and representatives compounded earlier errors.

The bad advice Rothko received resulted in a gross undervaluing of his estate and a protracted legal battle by his heirs (this is dealt with in some detail in the chapter on tax).

While professional advice is certainly essential, prejudiced advice can be as damaging as no advice at all. Careful research into all aspects of the commercial marketplace is the fundamental education one needs to make proper personal decisions.

CHAPTER 2

a history
of art business

The artist's traditional role as the manipulated martyr has a strong foundation in history: from the Greek and Roman workman, to the propagandist of the Church, to the servant of the State, to the present-day artists who often see themselves as at the mercy of the gallery system.

Over the course of several hundred years the status of the artist has gone in cycles—at one time raised to the level of a god and at another a mere functionary working at the whim of a rich merchant.

Throughout history, the producers of art have gradually come to recognize that they have a role to play as artists in society. That role varies from age to age, but in recent years there has been a consistent raising of artistic consciousness which has finally led artists to demand some control over their own lives.

Art history is traditionally taught in visual terms and rarely examines either the society influencing the artist or the market that absorbs the work.

If we are to understand the current highly competitive structure of the art market, it is important to understand how

it developed. History reveals that the artist today is not in an isolated situation, but has a long heritage to identify with.

The idea of the creative artist as distinct from the artisan is relatively new, for the status of the artist up to the fourteenth century was that of a workman. Nearly all painters moonlighted and doubled as decorators. We can find an artist like Verrocchio putting the finishing touches to death masks which kept him in sufficient funds to enable him to paint.

Treated as a carpenter or mason, the artist in Greek or Roman times was paid a fee for each completed work based on the amount of materials used and a price per item. So, one fee would be agreed upon for a head, another for either an animal sculpture or a painting. It was rare for an artist to create a work that had not been ordered in advance as the risk of not selling the work was thought too great.

As the power of the church grew, the role of the artist became more important. The church became the major sponsor of art and carefully maintained control over the product.

As early as A.D. 787 at the Second Council of Nicaea it was ruled that, "The composition of images is not the invention of painters, but is based on the tradition and tried legislation of the Catholic Church. . . . And the composition and this tradition are not things that concern the painter. To him is entrusted only their execution. Rather do they depend on the order and disposition of the holy fathers. . . . And in truth men learn to paint Christ's image under that appearance in which he was visible." In other words, artists were commissioned to paint only what they were told would be acceptable to the church.

As the clergy were the organizational go-betweens in art dealings, this edict had to be obeyed and was an early example of the limitations that have been imposed on artists' creativity throughout the course of history.

At the time of the Renaissance, there was a clear dis-

tinction between the Liberal Arts and the Mechanical Arts, with the "artists" belonging to the later. The Liberal Arts were taught at Arts Faculties and Universities and offered degrees which were available only to the wealthy intellectuals. Painting and sculpture were considered menial.

Artists had to rely on shop training for their education. The course of instruction could last as long as thirteen years, and the time was spent learning the new techniques of painting and sculpture. A general rule was that women were not allowed into the guilds, although exceptions were occasionally made for wives and daughters of guild members.

The major artistic outlet for women was through the convents where, with the support of the abbess, women could produce tapestries and illuminated manuscripts. Ende is one such artist who worked in Spain although it is the abbess who is better remembered for commissioning and supervising her.

Although there was a strong movement among some philosophers of the time to broaden the scope of the Liberal Arts to include painters and sculptors, the humanists fought hard to retain their position of privilege, and many artists felt humiliated by their low status.

Leonardo da Vinci never had the opportunity to go through the course of Liberal Arts, and although well educated, was looked on with contempt by the humanists. He described the members of the Liberal Arts as "puffed up and pompous, dressed and decorated with the fruits not of their own labors but those of others."

Enlightened in some ways as Leonardo undoubtedly was, he was guilty of the same sort of bigotry as the people he criticized. He refused to recognize sculpture as an art "because it brings sweat and bodily fatigue to him who works at it. . . . The sweat combines with dust and becomes mud with the face caked and the rest covered all over with marble dust so that he looks like a baker, and covered with minute chips so that he looks as if it had snowed on him,

and his house is dirty and full of chips and stone dust," as Vasari wrote.

The stronghold of the Liberal Arts began to show some signs of weakening, and toward the end of the sixteenth century, what we know as the Fine Arts was raised to a new position where creativity was at last recognized.

The transformation of the artist from artisan to a creative human being was completed in the course of some fifty years. Dürer and Michelangelo were two examples of artists with almost godlike powers. The idea was put forward that since artists were able to translate God's creations into recognizable form, they themselves must be closer to God than other mortals. It became the artist who was in demand and not the subject.

When this idea took hold, the work of art for the first time became subject to the laws of supply and demand, and the notion of art for profit and investment first took hold. Some painters, such as Raphael, were very much in demand and profited enormously from the new-found status of the artist. Others—the majority—lived in poverty.

Of course, the new stature of the artist in society, the high cost of securing his services and the laws of supply and demand produced a wide division between art and the people. The lower classes, even if they had wanted to, were unable to afford the expensive services of the artist and art became established among the elite.

The artists themselves were often unhappy with their positions of power, and finding it difficult to adapt to their freedom, they often abused it.

At the height of the Renaissance, the traditional control of the artist through the Mechanical Arts and the guilds was no longer compatible with the emerging role of the new artist in society. Thus, the first Academy of Art was established by Vasari in Florence in 1563, to tutor pupils in the Fine Arts.

Although the Academy, which was run on somewhat more restrictive lines than today's universities, succeeded in destroying the restrictive environment of the guilds, replacing it with an intellectual atmosphere, the artists were again brought back under the control of their peers.

While great changes were taking place in Italy, artists in the rest of Europe still suffered the restrictions of church doctrine. Traditionally, the church had supported the representation of images in the paintings of religious subjects, but the advance of the Reformation under the guidance of Luther reversed that policy in many places.

For the artist, whose main sponsor and often sole means of livelihood was the church, a difficult decision of conscience had to be made. Some artists *did* sacrifice their art for their conscience and suffered a great deal of hardship as a result.

As the struggle against the Reformation developed, the church resolved to use art as a propaganda weapon and decreed that nothing must distract the onlooker from the subject of a painting. Most of the great artists followed orders faithfully. For the Jesuit church in Antwerp, Rubens, who was already internationally known, painted thirty-nine panels in "accordance with the list provided by the Superior." Angels had to have wings and Christ always had to be on a throne of glory.

Anxious to counter the influence of the Protestants, the church worked to bring art back to the people, reducing it from the elite status it had held during the Renaissance.

By the end of the sixteenth century, artists were once more mortal beings and largely an extension of the church, with little room for freedom of expression or artistic creativity.

The successful rise of the artist in Italy had not been paralleled elsewhere in Europe, and it was not until Louis XIV ascended the throne of France that art was given any sort of recognition as a high human endeavor.

This time, it was not the church that was to make use

of the artist, but the politicians. Louis used all aspects of public life, including art, to enhance the splendor of the court and himself.

The Académie Royale de Peinture et de Sculpture was founded in 1648 to mold the artistic personality of the painters and sculptors to suit the court and Louis. The Academy was founded on the same principles as Italy's Academy of Art, except that in this instance royalist propaganda was the object, not the advancement of church policy.

To ensure complete control, Louis made the artists paid civil servants, who relied on their work's satisfying the king for their next paycheck. Eager to please, artists tended to distort history for the greater glorification of Louis and France. The annual exam at the Academy consisted in all the students painting or sculpting a general subject on the heroic actions of the king.

Many of the women who painted at this time became famous artists, although others remained in relative obscurity for some years. Sofonisba Anguisciola, for example, did family portraits and later became a court painter for Philip II of Spain. Conversely, Judith Leyster, who was one of Frans Hals' family and worked in the Netherlands, was not discovered until 1927.

Of course, artists who rely on the support of a system to survive are good only for as long as the system itself exists. When Louis' extravagances began to bankrupt the state, the position of the artist in society was threatened. With the severely reduced budget of the states, the artists had only the vagaries of the open market to depend on for a living.

The artist was no longer feted by society. They had to struggle to survive like members of the lower social orders. Their goods sold or they starved and they were no longer cossetted from the problems that faced ordinary mortals, and the wheel had once again come full circle. The Age of Romanticism was born when artists imagined themselves in a different world—a world free of the harsh realities of their

current existence. This escapism was richly illustrated in the work produced at the time.

Meanwhile, in Holland, artists had been fighting on the open market since the beginning of the seventeenth century without any of the political and religious restrictions that fettered artists elsewhere in Europe. Dutch painters, foreshadowing the twentieth-century artists, produced works in their studios at will and relied on chance to provide a living.

Middle-class Holland was enjoying the fruits of a healthy balance of payments and a laissez-faire attitude toward trade. The populace was also well aware of the value of art as an investment. One form of investment which many Hollanders believed to be an art form was the growing of tulips. Trade in tulips was rife in the early 1600s, and bulbs would change hands for fantastic sums. Special markets were set up for tulips, and a new post was created, that of "Tulip Public," to arbitrate in disputes between buyers and sellers. One Semper Augustus bulb changed hands for the equivalent of four thousand six hundred dollars, two dapple gray horses, a new carriage and accessories.

Inevitably the bottom fell out of the market and brought Holland to the brink of bankruptcy, so widespread and popular had the trade become.

This seeming compulsion of the Dutch to push collecting to extremes resulted in a huge glut of paintings on the market. The artists were in turn led to accepting very low prices for their works and eventually having to seek some form of alternative employment to survive.

Jan van Goyen became a realtor, Hobbema a tax collector, Jan Steen an innkeeper and Ruisdael a barber. Other artists, notably Vermeer and Rembrandt, set up as dealers.

Rembrandt's entry into the art market was organized by his family, who felt he was too extravagant to be allowed any substantial financial responsibility. While appreciating Rembrandt's artistic acumen, his family's fears about his financial responsibility proved justified when he went bankrupt. Ver-

meer was equally unsuccessful, as when he died his widow was left in total poverty.

Besides the painter-dealers, there emerged in the Low Countries in the seventeenth century a mass of professional art dealers who saw the opportunities presented by an over-supplied and under-promoted market. Dealers took up particular artists and made them sign contracts in which the artist undertook to hand over to the dealer everything he painted.

Thus, in 1647, a one-year contract was made between the dealer Bartholomeus Floquet and the painter Elias van den Broech. The artist was to receive a lodging subsidy of thirty-nine gulden, his food and an annual salary of one hundred twenty gulden, in consideration for which he was to be available at all times to paint for Floquet any subject that the dealer's commercial imagination might suggest. It was also specified that if the painter was absent for a day, or got married, he must pay damages to the dealer.

The dealers, however, did not have sufficient control of the market, which was still in the early stages of development. Those artists not under the control of the dealers continued to saturate the market with work. The result was a further slump in prices, and dealers thus turned to handling works of the old masters, which were in short supply and offered greater potential for profit. This development quickly became a point of contention between artists and dealers, as artists claimed that dealers should support and encourage the living rather than profiting from the dead.

The dealer was now here to stay. The foundation of the modern art market was being built. Galleries, catalogs and art critics were some of the building blocks.

Economic circumstances in both France and Holland forced artists to find alternative avenues for selling their work. One of these was the salon, which established public exhibitions so that the art could be introduced to prospective buyers. These salons were the forerunners of today's galleries.

Artists developed the idea of making prints of their work to distribute as advance publicity before the sale, and the Louvre, which until 1748 was the principal salon in Paris, produced twenty thousand guides to the works on display. Out of this practice developed the ideas of the catalog and printed criticism.

Allied to the printed criticism, which was merely a refined sales technique, came a more in-depth analysis of what actually constitutes art. Learned discussions were held at the Academy in Paris, and these discussions were published as essays or books for the student artist to study. Thus it came about that the intellectual, arguing the theories of art, dictated what the artist actually produced for, eager to get recognition from the great writers of the time, and to be accepted on the same intellectual plane, artists followed the lead of the academics and sublimated their own creativity to the ideas of other men.

The late eighteenth and early nineteenth centuries in Europe brought about profound political change as the old elitist system fought for survival. The bourgeoisie, among whom were the artists, were relegated to their former position subordinate to the noblemen. The harsh realities of that position led the artist to take refuge in a world of romantic unreality.

It was at that time that the idea of the artist as isolated and oppressed yet somehow above the real world was begun by the artists themselves. Unfortunately, such ideas only tended to remove them still further from the ordinary people with whom they hoped to communicate. The bourgeois were scandalized by those artists who believed in art for art's sake and who accepted few of the regimens of society. Society's rejection of the artist helped feed the idea of the artist as a misunderstood martyr.

However, as male artists were retreating from reality, women were beginning to consider art as a financial occupation. Elisabeth Vigée-Lebrun painted Marie Antoinette but

even that recommendation was not sufficient to get her fully accepted into society. Another woman artist, Lucille Guillard, had a hard fight to gain acceptance into the Academy. She was accused of having had a man paint her pictures for her. It was only after she had painted the portraits of the selectors that she was allowed to join the Academy. She also promoted women as professors and succeeded in having removed the previous limit of four women members of the Academy.

In the years both before and after the French Revolution, art was again used as a weapon of propaganda. This time, however, it was the artists themselves who chose to wage the war. Art, having only too often been a weapon in the hands of the ruling classes, now became a weapon of the people.

The most celebrated nineteenth-century artist who used socialist realism was Honoré Daumier. Some of Daumier's paintings were protests against the clerical, bourgeois and authoritarian regime of the Second Empire, and he attempted vast canvases of a moral message. His message was considered so effective by the government that he was tried and imprisoned for his work.

Artists were beginning to survive in the new dealer-dominated art world. In some instances, they had begun to recognize themselves as producers of a commodity, something that they had never ceased to be.

Gauguin was one of the earliest examples of the artist coping with today's demands in the art market, albeit in a rather cynical fashion.

After a period in Brittany, when he painted what some feel was his best work, Gauguin left France for Tahiti to look for new inspiration. While he was away, a carefully orchestrated publicity campaign ensured continued popularity for his work. When, in a moment of weakness, he considered returning to France, a painter friend advised him strongly against it: "It is to be feared that your arrival would disturb a process, an incubation that is taking place in public opinion with regard to yourself. At the moment you are the legendary

unique artist sending from the heart of Oceania his discon-
certing and inimitable works, the definitive works of a great
man who has disappeared, as it were, from the world. . . .
you enjoy the immunity of the great ones after death. . . .
You have passed into the history of art."

Gauguin himself was under no illusion as to the position
of himself and his work in the art market. He wrote: "The
future belongs to the painters of the tropics, which have not
so far been painted. The stupid buying public needs something
new by way of subject matter." (This is a marketing approach
that some galleries and some artists may be tempted to emulate
today.)

Up to now in the history of art, it had been the intention
of most painters to try to reproduce reality as closely as
possible. Then photography arrived on the scene. The first
exhibition was hung in the midst of paintings and caused
serious divisions within the Salon in Paris at the beginning of
the twentieth century. Some artists were outraged at the
mechanical reproductions of nature. Some artists began to
attempt to paint with total realism using photography as an
aid. Others deliberately moved away from realism. It is the
latter group who are thought to be the founders of modern art
and the Impressionist period.

Modern art is usually considered to be work completed
from about 1925 to 1960. Contemporary art is what is hap-
pening today. Obviously these dates continually change.
Picasso, for example, is considered a modern artist and not
contemporary. The Impressionists were a major influence on
the modern scene as the Dadaists are thought to be a major
influence on today's work.

Gradually photographers became aware of themselves
as artists in their own right and as members of a respectable
profession. The first Heliographic Society was founded in
Paris and a few years later a photographic salon was held
next door to the Salon of the Academy.

Degas was one of the artists most stimulated by photog-

raphy and even became a capable photographer himself. Other artists, however, moved away from the slavish adherence to the photographic image and, like Manet, for example, created works that were historically or physiologically inaccurate.

This pursuit of aestheticism in form and color only won the support of several contemporary critics who agreed with the idea of art for art's sake. Encouraged, the Impressionist artist gained acceptance and recognition from buyers and artists alike.

The Dada movement of the 1920s took the art world to the next stage of its development and the foundation of contemporary art. In the 1960s pop art effectively brought art to the man in the street through the works of such artists as Warhol, Lichtenstein and Rauschenberg.

And throughout all these years it has been the structure of the art market that has sustained the artists, or at least that they have been forced to deal with. It is only very recently that artists have begun to question their role in the traditional art establishment, and to explore alternative means of success both within that structure and outside of it.

CHAPTER 3

the
gallery

There is no doubt that an artist can create for a lifetime and never show or sell his work. Most modern artists, however, seek some degree of feedback, money and recognition for their work. Thus at some time they will most likely leave the anonymity of the private studio to look for a showplace, and the central showplace of the market world is the gallery.

PITFALL: Among the alternatives, the museum, with its expanding national achievements, is becoming a financially viable showplace while remaining an integral part of the spirit of prestige used by galleries to build the reputation of their artists. It is not the only alternative, however. In fact, the next chapter is devoted to the alternative space.

As stated previously, the art gallery is a business which must sell art to survive. Its technique for selling is to promote a certain "stable" of selected artists. The stable of artists differs in size from gallery to gallery depending on the facili-

ties of each. The stable also changes as artists choose other galleries or means of showing their work and others are accepted into it.

This chapter explains how galleries are organized, what services they perform for you and what they might expect from you.

Before examining different galleries to find the one that fits your needs, it is practical to limit your search to one city or one geographical area. Although New York is still the center of art in America, it is no longer the rule that you have to show at a gallery there before you can be a successful artist. William Wiley, for example, is gaining an international reputation while living on the West Coast and holding most of his shows in California. Cities such as Los Angeles, Chicago and Houston have the facilities to give an artist all the exposure he needs to gain a good reputation and some measure of financial success.

Most artists starting out in the world of galleries and dealers will tend to aim close to home, because it is less expensive to service a gallery and collectors in the immediate neighborhood than to deal with a gallery two thousand miles away.

There are several ways, aside from simple word of mouth, to find a gallery that fits your needs. These are some of them:

Gallery Guides. Most major cities produce a guide to their galleries, which can often be found at museums, galleries or the tourist office. Some directories will give only names and addresses. The search can be narrowed down considerably if the list also explains which galleries handle which different

PITFALL: Whatever guide you are using, make sure it is for the current year, as galleries often open and close, or move.

types of work. (See the section immediately following, "Choosing the Gallery.")

Advertisements and Paid Listings. All the art-related magazines, such as *Art in America, ARTnews* and *American Artist,* carry advertisements for galleries and current shows. Most newspapers have a weekly art column appearing alongside the advertisements for local galleries. Besides the advertisements, many newspapers carry complete listings of galleries in the area and their current exhibitions.

Art Groups. Your local branch of Artists Equity or Artists for Economic Action may supply names and addresses of reputable galleries they have heard about from their members. An approach to one of these groups has the added advantage of encountering a recommendation earned by honesty and integrity.

CHOOSING THE GALLERY

After finding a number of galleries dealing in your medium and style, you will do best to approach one or two among them.

Obviously, you are unlikely to find a gallery that suits your needs in every way, but the one that comes nearest and involves the least compromise is the one for you. Familiarize yourself with the gallery's catalogs, and then try to imagine how you might fit in. The information given here is intended to be useful to both the novice and the artist who has some experience in working with a gallery.

Type

Style or School. A gallery will probably specialize in work done in a particular style. If your work is abstract expressionist, there is little point in taking it to a gallery that deals in old masters.

Philosophy. You will, of course, want the other art handled by the gallery to work and not disagree with your own per-

sonal philosophy. The easiest way to check out a gallery's stable of artists and the work they are doing is to look at a group show. These often take place in the summer. The larger the show the better, as you will see a broader cross section of the work. You may have to spend some time familiarizing yourself with all the work on show. An alternative to this is to ask for a list of artists in the gallery's stable, which is often readily available.

Country or Area. Some galleries operate in only one small area and are not interested in handling work outside that area. Or a gallery may be international in scope and thereby reluctant to show an unknown local talent. On the other hand, there are New York galleries that specialize in California artists and galleries in London and Paris that deal exclusively in American work.

Joyce Rezendez, whose paintings are based on the mythology of the Hopi Indian, spent seven unsuccessful years trying to get herself established—in London. Once she returned to America and joined a co-op to get a one-person show, she was picked up by a New York gallery. Obviously, different art suits different parts of the world.

Medium of Work. Some galleries show a variety of media, while others restrict themselves to a specialty. If you have one medium or style of work, you are obviously going to pick the best examples of that work to show to a gallery that deals in that medium. On the other hand, if you work in several different media, you will choose the work according to the gallery you are approaching. If you work in two very different media, for example, oil painting and metal sculpture, you may have to use two separate galleries.

Henry Moore, the sculptor and lithographer, hires an art agent to handle the sale of his lithographs. The agent is a specialist in prints and can give better attention to their classification and distribution than a general gallery. The sculptures are left in the hands of various selected galleries in different parts of the world. Each gallery hopefully will

be able to place a few of the large works in museums, businesses or government offices or in large private collections. They will also have smaller works to sell in multiple quantities.

PITFALL: *Never ever* sign exclusive contracts for all your work with any one gallery if that gallery lacks the facilities to promote all the media you work in.

Ethnic. In recent years, the rise of the new consciousness has given birth to a new kind of gallery, aimed at giving exposure to groups which, to date, may have been inadequately represented. Galleries have been founded that cover many minorities, such as American Indians, Mexicans, blacks, women and gays. These galleries give valuable exposure to meaningful work but only in the context of their declared aims. If you feel that your work is particularly pertinent to one of the groups, this kind of gallery might be for you.

The Combo. Of course, some galleries will offer a combination of some or all the above. In that case, you must use your judgment as to how you can fit in.

The Physical Plan

Space. Obviously, if you have a sculpture fifteen feet high that you are considering for a gallery with eight-foot ceilings, the degree of compromise required might prove too great. Similarly, a large cavernous space will be unsuitable for work that is intimate in scale. Before dismissing the gallery for space reasons, however, check to see if the space can be made more suitable, such as with movable wall sections.

Light. Lighting is very important and can substantially enhance—or diminish—your work. For example, color photography does not need much daylight, but fluorescent light might totally destroy the effect of an oil painting. Again, check to see if the gallery has different lighting available.

Temperature and Humidity. Most modern galleries have

realized the importance of the proper conditions of the air for preserving the quality of the works, but in some struggling galleries, these precautions may be overlooked and delicate work might suffer damage.

Security. Because of strict insurance requirements, most reputable galleries take very good care of work left in their charge. Inadequate security can mean a poorly financed and badly managed gallery.

The Services

How well the gallery carries out its responsibilities can only be judged by its reputation in the art world. Witness this incident:

A new gallery appeared in New York in a very good area of town. The directors went to a juried show, obtained a list of those showing and wrote to all the participants asking them to submit work for an inaugural exhibition at the new gallery. Many of the artists sent their work to the gallery, which looked very prestigious. Then two days before the show was due to open a truck appeared, loaded up all the work and left town along with the gallery directors. None of the artists had bothered to check out the gallery before entering their work, and none of them had obtained any form of documentation.

To safeguard your work and your reputation, check out the following points of any gallery you plan to associate yourself with.

Sales. Find out how successful the gallery is with its collectors and what its reputation is with them. The kind of collectors who patronize the gallery can also affect your position in the art market.

For instance, if the gallery deals mainly with private people, you must bear in mind that most work it handles has to fit into a home in order to be sold.

Famous collectors, on the other hand, in addition to being prepared to pay high prices for work, often have special

exhibition areas for display. If your work is bought by a famous collector, your dealer is sure to publicize that fact, and your reputation will benefit considerably. Only one or two such sales may in fact put you well on your way to a profitable career.

The fact that museums buy from a particular gallery is a definite seal of approval, and means the gallery has a very good reputation.

A gallery that concentrates on selling to business and industry probably handles a lot of commissioned works.

Promotion. This is one of the gallery services that is immediately visible. You can examine the general promotion campaign to see what sort of exposure the gallery—and its stable of artists—gets.

Take a look at the publications produced by the gallery including invitations to openings, catalogs and press releases. Look in magazines and newspapers to see what their advertisements look like. A full-page ad in a magazine such as *Artforum* costs a lot of money, and you can be sure the gallery expects the investment to pay off.

The ability of the gallery to get unsolicited exposure through reviews and general articles is also important.

Exposure and Feedback. The degree of exposure your work gets and how fast word of your work spreads in the art world are good clues as to who is actually seeing the work. Before you choose a gallery, a quick look at the gallery guest book may give you some idea of the kind of collector who frequents the gallery. Check with the receptionist to see if school groups or clubs are welcome. Keep your eyes open when you visit the gallery to see who is there and how they are treated. Some galleries cultivate an air of exclusiveness as part of their promotion campaign. It often helps sales, but you must decide if it is the best atmosphere in which to show your particular art.

Business Reputation. Artists Equity, Artists for Economic Action, the Better Business Bureau and other artists can

help you determine how sound the gallery's financial dealings are.

Advances. Some galleries are prepared to make a cash advance to their artists against future sales. Depending on your financial circumstances, this could be very useful.

Peter Bettamy was a sculptor who had a show lined up for display in a community gallery. At the time, however, he lacked enough money either to make the sculptures for the show or to support himself while he did it. Although his gallery was unwilling to advance him any cash it could apply for a grant on his behalf, which would enable him to put on the show.

Commissions. In general, you can expect a co-op to charge about 10 percent commission on top of various membership fees. Average commissions now charged by established galleries are 40–50 percent. In rare cases even more can be charged for a specific commissioned work. However, as in most things, you generally get what you pay for, and a lower commission could mean you are missing out on some essential services. For more information on commissioning see Chapter 8, entitled "Receipts, Agreements and Contracts."

Commissioned Work. Though commissioned work can be in any medium—murals, tapestries, photographs, to name a few—large sculptures have a substantial share of the market. Therefore, if you produce only very large work, it is almost essential to find a gallery that handles commissions. Some galleries don't, so be sure to check.

Rentals. Some galleries will rent work to businesses or private people. If you want to keep hold of your art but need a steady income, renting might be the answer. If a gallery uses a renting system and accepts your work, there is a chance

PITFALL: It is very important to insure your work carefully as a high percentage of rented work gets damaged.

that some of the renters will eventually buy your work. Either way, you participate in the profit. Some museums, such as the Nelson Gallery of Art and the Atkins Museum of Fine Arts in Kansas City, and the Museum of Modern Art in New York, have rental galleries as well.

Foreign Markets. During your first venture into the art world, selling work at home is going to be more important than getting a reputation in London or Paris. However, many artists are able to stay with one gallery for a long time and thus build a very good relationship. At the outset, therefore, you can make a good investment for the future by approaching a gallery with good international connections.

Besides promoting your work to foreign collectors, such a gallery may show at art fairs in Europe, where your work will get valuable exposure to other members of the art community.

Richard Diebenkorn is a painter who lived and made a good reputation on the West Coast. Although he was represented all along by the Poindexter Gallery in New York, his career never reached the international stage until he joined the Marlborough Galleries and was promoted on the international market.

Diebenkorn recently had a retrospective that started in the Albright-Knox Art Gallery in Buffalo and went to the Oakland Museum, Oakland, California, and then on to the Los Angeles County Museum of Art to be seen by record-breaking crowds, something that would have been virtually impossible had he remained with his California gallery.

If you are planning to live abroad, cultivating a gallery with good foreign connections has even greater value.

GETTING INTO THE GALLERY

Once your research is complete, you may feel absolutely convinced that you have found the perfect gallery. One small problem remains—bringing that fact to the attention of the

gallery director and convincing him, or her, that you would be a valuable asset to its stable of artists.

The best, most successful method is to approach one of the artists that the gallery already deals with and show your work. The artist won't mind being approached if it is done tactfully and politely. It is assumed that you respect the artist if you want to show in the same gallery, and it is your work that is your common bond of communication. Chances are the artist started off in the same way.

That the gallery will pay far more attention to a recommendation from someone respected by the gallery director, particularly if that someone is already on the gallery's books, than they will to someone off the street, cannot be over-emphasized.

If you fail to get an artist to recommend you, a referral from a museum also carries a lot of weight. Critics and other art galleries refer so many artists that their word does not register quite so clearly.

If you cannot arrange any of these, follow the guidelines in Chapter 5, "The Presentation."

CHAPTER 4

the alternative space

Failure to get accepted into an established art gallery does not mean the end of your career as an artist.

Many artists in recent years have viewed the traditional art gallery structure as being both too elitist and too rigid. For this reason, alternatives to the gallery have been increasing in popularity. Some have been around a long time. Others are fairly new. The opportunity for artists to have control over their own representation has never been better, and public awareness is increasing of the artist's right to a say in what happens to his creation.

A recent article in *ARTnews*, "Rooms with a Point of View" by Kay Larsen, lists three main factors behind the rise of the alternative space: politics, economics and power. Artists are not allowed to participate in the existing decision-making structures and often have no wish to become involved, she stated. "Art itself has changed, has removed itself into realms that cannot be so easily pinned down by systematic aesthetics or phenomenological/philosophical generalities."

While many artists may be sympathetic with that point of view, it should be remembered that the alternative space is

simply that, and not the road to instant commercial success.

When one alternative space, the Los Angeles Institute of Contemporary Art (LAICA), opened in 1972, the event was celebrated in a manifesto by the artist Walter Gabrielson: "This new institution opposes the collective indifference and the politicking of the area's straight institutions, controlled as they are by a ubiquitous handful of money-persons . . . hell-bent on traditional collecting, edict-mongering, art collector validating, nouveau-riche social authenticating and safety-in-scholarship programming."

The larger, more established alternative spaces, because they are often useful sources of new talent, are closely watched by commercial galleries and museums. In addition, if you choose to run an alternative space yourself, it can be a way to gain national recognition both as a gallery director and as an artist. That was just the experience of Jerry Saltz of N.A.M.E. in Chicago and Jim Pomeroy, originally of 80 Langton Street in San Francisco and now with the National Endowment.

There are several different methods of obtaining or operating an alternative space, the most common of which are described in the following sections. The artist, of course, must make his own decision as to which is the most suitable for his needs. In addition, a national conference of alternative spaces is held annually, and should be examined closely, as the field is developing rapidly.

PRIVATE DEALERS

Because he doesn't have the heavy overhead of a gallery, the private dealer, who sells from his home or directly from your studio, will charge the artist less commission. Also unlike a gallery, he usually does not advertise and relies for his business solely on word of mouth.

AGENTS

Performing the same sort of function as a literary or film agent, the art agent will act as your representative in the business world. He or she will handle all negotiations with galleries and collectors, even private dealers and museums, and will endeavor to place your work in shows regularly, to sell the work and to generally promote your reputation.

Agents are fairly scarce. If you can find one, you will have to pay a regular retaining fee and/or a percentage of all sales, regardless of whether or not the agent initiated the sale.

A full contract should be negotiated with an agent if you obtain such a service. The section in Chapter 8 on contracts goes into more detail on items to be considered.

SELLING FROM HOME

This is perhaps the simplest alternative available and creates the fewest problems with the art world. Of course, because direct contact with the world of exhibitions and sales is fairly remote, the chances of high financial success are slim. If that is unimportant to you, however, and you wish only to survive through your art, then this method is perfectly feasible.

There are several things to pay attention to:

Mailing List. The scope of your gallery at home will depend largely on the time you take to prepare a mailing list. Generally, you can start the list off with recommendations from friends and build from there. It will require considerable time and patience to build up a list of people who might be interested in your art.

When you hear of a potential buyer, you might invite him to your studio so that he can get to know your work. Keep a note of what each collector liked and when each was last contacted. Every two years you may want to revise your list.

At that time you could send stamped return forms to those collectors from whom you have had no response, asking if they wish to remain on the mailing list.

Exhibitions. At the outset, the expense of putting on a show may prove prohibitive, but after a broad list of potential buyers has been built, one show a year should be considered. Any more will strain the collector's buying ability. Shows need to last only one day, or perhaps two if you have a long list of prospective buyers.

A printed invitation should be sent to everyone on your mailing list, stating clearly your name, the medium to be exhibited, the dates and times the works can be viewed, the address of the exhibition (including a small map if necessary) and a telephone number for further information. A place in your studio can be arranged, an exhibition hall could be rented or a friend might have a suitable place to show your work. The range of work shown should cover the range of people invited to attend. Some works should be framed, but not necessarily all. Hanging an exhibition does take some degree of skill. Attention should be paid to sequence, hanging height, lighting, labeling and the general tidiness of the installation. A price list should be readily at hand.

After the show, follow up on those collectors who appeared interested but did not make any immediate decision.

Partnership. To cut the running costs in the studio and to share other art-related expenses, you might consider approaching another artist in a position similar to your own about going into partnership. Such an arrangement has obvious advantages, among which is the fact that your list of potential collectors should double.

It is very important that all business arrangements be laid down in a contract between the two parties. Although you may be very good friends, business relationships have an unfortunate habit of turning sour. On those occasions, it is best to have all agreements in writing.

Incorporation. If you have no connections with art galleries, you will be able to incorporate your art business. This is worthwhile only from a tax point of view and only if you are quite successful. At that stage you will also need to take the advice of an accountant.

The tax position of artists who have studios in their homes is fairly complicated and is dealt with more fully in Chapter 10.

EXCHANGE OR BARTER

Many professional people, such as doctors and dentists, are art collectors and may be prepared to take your work in exchange for their services. This is a very common practice and worth trying. It is also possible to barter art for food or services among your friends. Such exchange of material is generally not subject to income tax—another obvious advantage of the barter system.

RENTING SPACE

January, July and August are often dead sales periods for galleries. During those months it may be possible to rent all or part of their space to show your work. It may occur to you that there is little point in spending good money for rental space when the gallery itself feels there isn't any market. Remember, however, how all-important is exposure, and that any opportunity to show is a chance to get your name known by the public and the critics. This method is often used by artists in small cities who find it necessary to show "big city" names on their resumes.

It is also an opportunity to see one's work in a new and neutral surrounding, which can be very beneficial and quite refreshing.

COOPERATIVE GALLERIES

The co-op gallery system began after World War II, with artists, friends and relatives helping with the installation work and running of the gallery.

Particularly in the last ten years, the co-op has been firmly established as an alternative art space. In its infancy, the co-op was envisioned as a unit operated by artists for artists, and free from the restrictions and domination of the gallery structure. Reality has proved that philosophy somewhat simplistic, and most co-ops have had to make some concessions to the business world, but there are still some advantages to the artist of such an arrangement.

Today, the most professional of such galleries are run by a managing director who is responsible to a board of directors composed of artists. The ideals of the unstructured environment generally have been found to be too disorganized to work efficiently, although some co-ops still firmly maintain their complete independence from conventional gallery methods.

And some of the most professional co-ops are even beginning to compete with the traditional gallery on its own terms. The Los Angeles Institute of Contemporary Art, for example, will be buying television advertising time in the near future to advance the cause of the alternative space in California.

In a co-op, the policies are decided by the members. One major decision is the number of members and the frequency with which each member shows his work. (Often there will also be a room set aside at every show to exhibit one work by each of the other members.) If the members want one show a year for a month each, this obviously restricts the membership to twelve. At the other extreme, if members wanted a show every four years for only one week each and the gallery had two showing spaces, the figure would rise to four hundred sixteen members. The membership might de-

termine its showing schedule according to seniority or a subjective vote of its directors. In any event, it is common practice to accept new members to an existing co-op by a vote of the membership.

Funding by co-op members is generally achieved either by a monthly fee, which may or may not cover the artist's own exhibition expenses, or by a yearly fee, usually a higher figure which includes most exhibition expenses. Commissions on sales can vary from zero to about 25 percent—again a matter of policy for the individual co-op. Figures will vary greatly depending on the overheads and number of members of a particular co-op. For example, one co-op may charge a fee of fifty dollars with a commission of 20 percent, not including exhibition costs. Another may charge a flat one thousand dollars, with 5 percent taken for commission, which covers most costs. Both figures would be for showings once a year for each artist.

Whatever co-op you choose, be sure to check all the details of membership thoroughly before you make any commitment.

At the end of a year's involvement with a co-op you may find that you have spent as much money in dues and commissions as would have been spent with a traditional gallery. You must weigh that fact, however, against the advantages of having had control over the exhibition of your work and the support of people you respect.

If you and a group of friends decide that the facilities offered by the existing co-ops do not meet your needs, or that the community has no realistic alternative space, it is possible to set up your own. In doing that, these points should be remembered.

Organize Early. The sheer volume of work needed to set up a gallery will take *at least* six months, so don't be too ambitious about an opening date.

The Artists. Complete cooperation is very important during the formation period. It is essential to have people you

can work with and who are prepared to compromise over difficult issues.

Quarters. One artists' group went to their local redevelopment agency and found condemned buildings that they were allowed to use on a temporary basis. It is helpful to point out to the agency that an occupied building has less chance of being vandalized and is not an eyesore. But remember, the space is scheduled for destruction and will not be a permanent home. Improvements should not exceed a time ratio of use, and most equipment should not be permanently installed. Also, avoid using buildings that the local historical society may feel are worth saving, or you will lose the space.

Of course, there are a number of more permanent spaces that are suitable for co-ops, such as store fronts, factories and empty offices. Try to choose a structurally suitable space where only cosmetic repairs and removable equipment are needed. Once you become successful, contractors and architects can be used to improve or even build a space to your design.

Inspection. Before you spend any money on the building, have it inspected by the city fire and health departments. They will be able to advise you whether it is worth saving.

Cost. A carefully planned budget will go a long way toward the success of the gallery. A friendly accountant might advise you free of charge, or in exchange for art works. Include in the budget such items as rent, heating and light, entertainment, equipment, depreciation, maintenance, insurance, telephone, advertising and salaries. Remember barter as a possible means of payment in each case.

Allow at least 10 percent for contingencies, as it is inevitable that some items will be over budget and there will be others that you have forgotten.

Fund Raising. The opportunities for raising funds may depend on how deeply you are committed to staying away from establishment sources. With skillful use of every con-

tact you have, it ought to be possible to form a "Friends of the Co-op" group to act as patrons and help raise capital.

Aside from those private sources, there do exist philanthropic business organizations. A direct approach for funds costs only a letter and just might be successful, though without some contacts within the organization, that is unlikely. Fund raisers can be hired, but such a traditional method is sometimes offensive to a group of artists seeking alternative means.

Support from state or federal agencies will not be forthcoming until a co-op has survived at least a year. Grants from the National Endowment for the Arts for the major alternative spaces run in the range of eight thousand to fifteen thousand dollars. The monies are given out in ways that allow the spaces to defray costs of rent and salaries, as well as exhibitions.

PITFALL: As the space takes on the characteristics of an institution, it may no longer serve the function of an alternative.

The most reliable source, of course, is the artists in the co-op themselves. A small contribution from each will underwrite the running costs.

Officers. However democratic the organization may be, it is essential that someone or some group take responsibility for each of the different aspects of the operation such as fund raising, exhibitions and the screening of applicants wishing to show. The usual method is to elect a committee for each function, which in turn is responsible to a coordinating group, also elected by the members. As stated previously, many successful co-ops have raised funds to hire a director. The director, an employee of the co-op, coordinates activities and

takes final responsibility for the tasks set forth by the membership.

Work Schedule. The officers themselves will undertake much of the work, but there will have to be some delegation. Obviously, artists will want to help in the hanging of their own shows, but everyone in the co-op should be prepared to do a portion of the general work.

Mailing List. Instead of relying on people coming in off the street to view the work on display, it is better to build up a list of people who will be interested in the art the co-op will be showing. A comprehensive mailing list has the added advantage of providing a ready source for fund-raising drives. Each member should be contributing to this list constantly, especially at the time of his own show. The membership list of a local museum or art club would be a good start. The professional members of the community, the doctors, dentists, lawyers and so on, are also renowned supporters of the arts.

Gallery Hours. If the work exhibited in the gallery is to stand a good chance of selling, the public must be told when the gallery will be open. These hours should be adhered to whenever possible, as a prospective buyer will not be encouraged to purchase if on arrival at the gallery during an announced opening time he finds it closed.

PITFALL: Co-ops traditionally use members as gallery sitters. A deep commitment to one's own work and an extra hour at the canvas when the light is just right can often cause irregularity in the opening hours of the co-op. Reliability is essential for a successful co-op. The collector is usually a busy person and a wasted hour of frustration waiting at a closed gallery door will almost certainly mean the loss of a sale.

Publicity. Most newspapers and television stations are only

too pleased to have news items handed to them. It saves them work and keeps the programs full. Always try to prepare a statement for the media that can be broadcast as written.

Careful cultivation of contacts in the media, especially critics, can prove an invaluable aid to the establishment of the co-op as a viable alternative space.

Tax-Exempt Status. If the co-op proves successful, it is well worth establishing it as a non-profit organization.

In 1970, members of the International Association of Artists meeting in Amsterdam suggested the idea of tax-exempt galleries as an alternative to the commercial gallery. These would be funded by the National Endowment for the Arts or state councils through grants. The gallery would be run by a foundation-appointed director, and private dealers would help with sales. The gallery would also employ artists on a part-time basis to help finance their art.

We have yet to see this scheme in full action, although there do exist alternative galleries that are tax exempt and funded. It would be a wonderful way for a gallery director, not interested in or particularly adept at sales, to pull together a strong, interesting group of artists who were not themselves interested in the co-op ideal.

After you have formed or been accepted by an existing co-op gallery there may be several day-to-day responsibilities that you as a member should be prepared for.

For example, a co-op that an artist we know has joined has thirty-six members. Joyce pays twenty dollars a month toward the running costs of the gallery and is looking forward to her next month-long show, which is scheduled every three years.

The co-op has hired a professional gallery director to supervise the daily operation of the gallery and to handle sales.

Once a week, if the director needs to be absent, Joyce goes in for a half day as a gallery sitter to keep the space

open. She rotates this volunteer work with other jobs such as addressing and sending the invitations for each show or helping with the hanging of an exhibition.

She will pay for her own framing, a color brochure and an opening party for her show. She also pays an additional three-hundred-dollar show fee, as her co-op must meet a high rent and the expense of a director.

Joyce tries to attend most of the openings at the gallery to show her support for the artists, and often volunteers to bake something for the event. More important, she knows several critics in the area and endeavors to bring them to the gallery during the course of any exhibitions she thinks might be of particular interest to them.

She doesn't know many collectors, but other members of the co-op have wealthy friends, and the director was hired partly with an eye to his connections.

One or two of the members are from out of state and pay an additional fee because they do no volunteer work. However, Joyce has been able to set up a show for herself in one of their hometowns, which resulted in some sales. The out-of-town members felt that the big-city credit on their resumes gave them added status when marketing their work.

Further information about co-ops can be obtained by getting in touch directly with the co-op of interest to you. A selection of alternative spaces run mostly, or completely, by a board of directors who are artists is listed in the Appendix under "Resources."

JURIED SHOWS

A juried show is one where artists are asked to submit work to a judge or panel of judges after paying an entry fee. Selectors choose work in their own way and make up an exhibition which may or may not have a printed catalog to accompany it. Often, but not always, prizes are awarded to

certain artists in addition to the privilege of being accepted in the show. In some instances a group of artists might be invited to show their work, as in an invitational. These works will be shown with the selected works and this practice can make for an interesting exhibition.

Many artists feel that juried shows offer the only realistic alternative to the gallery system and are a good way to get exposure. No doubt that is true in some cases and many juried shows are highly reputable.

However, because so many artists have been willing to pay for exposure through juried shows, some unscrupulous businessmen have taken advantage of the artist to make a great deal of money. The most common way is to accept fees for a number of works, then actually place on exhibit only a small percentage of those works. Out of perhaps thirty thousand dollars in receipts, two thousand may be paid out in prize money with the remaining twenty-eight thousand going to the organizer.

There is a strong movement to ban shows that charge a fee to the artist and then do not exhibit the work. The National Endowment, for example, will not award grants to organizations that charge a fee to enter a juried show. Other artists' rights groups are taking a similar stand.

Each show must be judged on its merits, and there are several things the artist should be advised of before submitting work. These matters should all be included in a contract supplied by the exhibition organizer. Failure to provide such a contract should make the artist suspicious of the intentions of the show organizers.

The contract should include the following information:

Dates. This will cover all the dates relevant to the show, including final work-submission date and the date work will be returned to you either before the show or after it if your entry is not accepted.

Costs. It is to be hoped that there will be no fees to the artist, but if you decide to enter a fee-paying show, make

sure you know the exact cost and what you are getting for your money.

Commission. Some show organizers may try to recover the cost of putting on a show by charging commissions on the sale of any work. You should *not* be charged both a fee and a commission.

The organizers must be held responsible for any credit risks incurred when selling a work. They will also pay any taxes due.

Insurance. Generally, the organizers will handle the insurance of your work. Make sure you are getting adequate coverage.

A photographer's pictures submitted to a juried show can be damaged because they have been exhibited with no glass protection over the image. (The organizers of such a show may not ask for work to be submitted already framed.) Make sure the application form states how the work is to be exhibited. If there is no such information on the form, send a covering letter asking for the work to be returned if it is not to be hung to certain minimum standards, which you should outline.

Transport. Normally, you are responsible for submitting your work. If the show is out of state, the show organizer might agree to sharing part of the transportation costs.

Publicity. All matters relating to publicity, including adequate public relations, preparation of a brochure and an opening party, will be at the show's expense.

Donations to Charity. Juried shows are often sponsored by charities, who hope to get contributions from artists. Whether or not you contribute your work to charity is up to you. Just remember that you can deduct only the cost of materials from your income taxes and not the total value of the work.

Jurors. The organizers should inform you who the jurors are so that you will be able to judge their independence and impartiality.

Juried shows can be found listed in art magazines and newspapers. It is also a good idea to look on bulletin boards in art schools and centers.

MUSEUMS

Museums are the most public aspect of the art establishment. Artists are often reluctant to approach museums because they fear either rejection or, perhaps worse, the overriding of their own aesthetic ideas.

The view of museums as indifferent to contemporary art has been considerably altered all over the country under a new generation of enlightened directors and curators. Now, many museums can be viewed as an excellent alternative to the traditional sales gallery in terms of exposure, and many are receptive to new artists. It should be remembered though that museums can generally provide only occasional exposure.

It is possible now to show your work directly with museums if you have the right contacts with museum personnel or directors. Work does not necessarily need to be saleable, but obviously must be of some interest to the policies of a particular museum. Because of its size, *The Dinner Party* by Judy Chicago does not have a ready market, but it was shown at the San Francisco Museum of Modern Art because of the enthusiasm of Director Henry Hopkins. Other works of an experimental nature are supported, as well as earth works and self-destructing art. A fine reputation can be built with the help of city, state and private museums and art galleries. Sales from this exposure, if one wishes, can eventually be turned over to a gallery, private dealer or agent.

As usual, there are several things to be remembered if you are considering approaching a museum.

Sales. Museums do not act as agents, but they will occasionally buy a work if they are aided financially by a local fine arts society. They will only rarely purchase work using

their own acquisition fund for the whole purchase price. Neither kind of purchase can be counted on to occur on any regular basis.

Geographic Area. Unlike some sales galleries, you can approach museums all over the country, as they generally have no restriction on the area from which they accept work.

Juried Shows. Many museums sponsor juried shows and award cash prizes. Some museums still charge an entrance fee, but, under pressure from art groups, the practice appears to be dying out.

Slide Submission. All museums welcome slides, which can be submitted directly, without having to go through a dealer. Return postage should accompany these.

Viewing Days. Some museums have a specific day allotted each month for artists to present, in person, their slides and/ or work. A telephone call to the museum will tell you the day and you will probably be able to make an appointment. Approaching a museum is similar in concept to approaching a gallery—the person seeing you will appreciate it if you have taken the trouble to telephone in advance. It is not advised that you turn up expecting instant service.

Work Donation. Museums will often buy work they like and it is not always the case that you will be expected to make a donation. Of course, if a museum asks you to donate a work, you must decide for yourself if the prestige acquired is worth the sacrifice.

Reproduction Rights. All works, whether donated or sold to a museum, are generally acquired complete with all reproduction rights. It is advised that you attempt to negotiate this point.

Buy Back. If the museum decides to sell a work you have either donated or sold to the museum, you may negotiate to have the first option to buy the work back. Some museums still refuse to include a "buy back" clause in any agreement, but again, attempt to negotiate the point.

Shipping. The museum will not always pay for shipping your work to its premises, even if it is a donation. Make sure there are no hidden costs before you agree to anything.

Exhibition Facilities. Most museums have an art gallery on the premises which is used to show unknowns. Even if the museum is not interested in buying your work, it may be prepared to provide exhibition space.

Renting. Often, museums have art-rental galleries for their patrons in the hope that they will subsequently purchase the work. If the museum you are approaching suggests this, make sure you agree to the terms of the fee, insurance, duration of agreement and shipping.

PITFALL: Bear in mind that any decision concerning your work may be influenced by the vested interests of the museum trustees and the curator, who may himself collect and, therefore, wish to promote certain artists.

PUBLIC BUILDINGS COOPERATIVE USE ACT

This act has made major public buildings all over the country accessible to the general public for commercial, educational and recreational activities.

The General Services Administration, which looks after most public buildings, has been instructed to "provide and maintain space, facilities, and activities, to the extent practicable, which encourage public access to . . . public buildings."

Artists interested in showing their work to the public are now able, often free of charge, to hang a show or provide a performance in a public building.

If there is a building in your area which you think you can improve with your art, contact the local branch of the GSA under "Public Buildings Service" in your telephone

book. If there is no office in your area, write directly to Federal Design Program, National Endowment for the Arts, Washington, D.C. 20506.

The GSA will want to know, in detail, your plans for the building and, in particular, your ideas for covering the cost of insurance, hanging the show and publicity.

The GSA will not be prepared to help finance the show, but this is an excellent method of getting exposure for your work.

For more specific information on commissions from the GSA see the section "Art in Public Buildings" in Chapter 11.

INTERNATIONAL ART FAIRS

A certain number of International Art Fairs are held every year. In the recent past they have taken place in Switzerland, Germany, Italy and the United States. They are held usually in the spring, early summer or fall and in Europe are generally coordinated with the important auctions. Listing for these fairs, which are open to the general public, can be found in the higher-priced art magazines. They usually last a week to ten days.

Although called art fairs, in many ways they are more like company sales conventions. Galleries rent space in an auditorium and set up a mini-display either featuring one artist or showing a sample of the artists that the gallery represents. There are also booths rented by art book publishers, framers, shippers, and insurers.

The auditorium is generally arranged according to country, which provides an excellent opportunity in a very small space to take a round-the-world gallery trip. You walk down one aisle perhaps situated in Paris, turn the corner and are transported to Florence.

Each space is manned by a staff member of the gallery who is very often the director, and this is a very good oppor-

tunity for the artist to meet the director, judge the sort of work shown in the gallery and make useful contacts.

A gallery will sometimes bring an artist it is currently promoting to the fair but more usually this is an occasion to make sales, exchange shows and meet museum curators and collectors.

There is absolutely no reason why you should not make an unsponsored visit to the fair. Take along a resume and a selection of slides illustrating your work and talk to any gallery that appeals to you. If you are interested in a particular country you might discuss with a gallery from that country other exhibition spaces not represented at the fair.

Although it would be unlikely that you would actually sell any work at the fair, you might be able to arrange an exhibition in the future or make contact with a gallery interested in seeing actual samples of your work.

An art fair provides a very useful opportunity for you to keep in touch with developments in your field that are going on in other countries.

CHAPTER 5

the presentation

First impressions can make or break an artist. Throughout your career it will be important to develop a sense of whom you need to approach and how you can best present yourself and your art to them. The general term "gallery" will be used in this chapter to signify all exhibition spaces. Our chapters on galleries and alternative spaces will help to inform you on the choice.

It is not recommended that you walk in from the street on the chance that you will see a director. You should make an appointment in advance. Many galleries see hundreds of artists or receive slides from as many each year. They are used to seeing people with little or no talent, who have no idea of how to present themselves or their work. Your task is to convince the person you see not only that you have talent but that you are the right artist for that space.

This chapter covers many of the matters of personal preparation that have to be organized well before you even step out of your studio.

THE RESUME

No matter how short your resume might be at the beginning, it is the start of your life-long professional documentation and should be updated at every stage of your career.

The resume is a biographical sheet used by the artist to inform the gallery of his vital statistics. It is also used by the gallery to prepare press releases or catalogs and to provide general information to people interested in buying the artist's work.

The standard resume form can be found in the Appendix. However, as an artist, you are expected to show some individual flair. You must bear in mind the purpose of the resume and produce it with clarity and care so the gallery will know that you approach your work seriously.

The gallery will treat your resume as a non-returnable brochure. Make sure that it is left with someone who might conceivably be interested in your work. In that way, your name will be remembered by more people and your professional history registered with those who may one day want to show or buy your work. It's also a good idea to keep an informal list of whom you've given your resume to.

The following is a list, with some comments, of subjects that should be included in your resume.

Name, Address and Telephone Number. Remember to adjust your resume when you change residence, and to inform those who have your resume on file of the change.

Place and Year of Birth. Don't list your age—your resume might rest with a gallery for several years.

Schools and Qualifications. This applies only to work on the university level. Include all degrees that were obtained, with the major, and the year and the date of each achievement.

Exhibitions. Solo and group shows where your work has been exhibited should be listed in chronological order. In-

clude the title of the show, whether it was juried or not, the place and the date.

Prizes, Scholarships and Awards. Again, this only applies to post-high-school education. Make sure to include the place, date and year.

Collections. List prominent private collections, museums, universities, corporations or famous artists who have exhibited or purchased your work. Remember to include the city, state and country where the work is located.

PITFALL: It is not particularly impressive to see a long list of private individuals (your friends and relatives) listed in the resume. Save these names to use as a mailing list for future sales.

Reviews and Publications. If you do not have any reviews, you might purchase the services of an essayist to write a review and description of your work. This can be done by approaching local newspapers or magazines, but can be fairly expensive. An approach to art history professors, graduate students or even knowledgeable friends can be less costly. A review is not necessary for most galleries, but is often useful for collectors who might need the added reassurance of a critical evaluation.

Some real insight into the aim and direction of the work should be commented upon. A comparison to earlier work is always interesting, but avoid comparisons to other artists. You are seeking to establish your own particular style. When articles or essays about you or your work are printed, these should be listed with the title, author, publication and date.

Personal Bibliography. List any articles or books written by you. Include the title of the work, date of publication and the publisher.

Professional Organizations. List names and any positions held.

Art-Related Professional Experience. Many galleries will be interested in the fact that an applicant is a teacher in an art school or a studio workshop assistant, or has some other working knowledge of the business.

Work Illustration and Statement. It is always a good idea to include a reproduction of one typical work, or if that is not possible, a brief description can suffice. The statement, no more than one or two paragraphs long, should cover your subject areas or philosophy, as well as the medium or media used. These are simply to remind the reader of the work or slides already seen, and need not be a complete justification of your art.

Photographs. A picture of yourself in the file along with the resume will help the gallery to put a face to the facts and may help recall significant information from the first interview. Instead of stapling two photographs to the resume, a more professional approach is to have the information and photographs reproduced as one sheet.

Your resume will expand over the years and, it is to be hoped, become quite lengthy. It may then become necessary to compile an abbreviated version. This resume should be only one page in length and thus list only the most impressive of your accomplishments along with the vital statistics. The shortened form can still be used as a give-away sheet.

SLIDES

The best way to introduce anyone to your work is to show the original product. Of course, that is not always possible, especially when the works are large, and a gallery is never very happy when an artist shows up eager to unload a small truck of paintings or sculptures into previously allocated gallery space. Under these circumstances, slides are an obvious,

and quite acceptable, solution. And even if your work is small enough to be taken directly to the gallery, slides will be necessary for proper documentation, registration, copyright and publicity.

Producing a quality slide that will do justice to your work is generally not an easy task. Although it is possible to obtain adequate results yourself, you might consider hiring or bartering for the services of a professional photographer.

If you are near a college, a trained student or faculty assistant working in the photography department will do the work more cheaply than a professional, and often with more care and attention. Do ask to see other slides of artists' work that they have taken, though, because photographing art is a specific skill. The slide library in a large university art department is usually set up to take slides of small flat work. This service is often extended to art students.

If you choose to do the work yourself, here are several suggestions that may help.

Photographing Outdoors. For the amateur, because of the difficulties of obtaining true color with inside lights, best results are reproduced outdoors. A 35mm camera, fitted with an automatic light meter, will be best. The work should be placed against a relatively neutral background (such as gray) but not against white. If it is not possible to get a uniform background, when the slide is developed, mask the unsightly areas with dark tape. This has to be done with care so that the slide will still fit into the projector. Use special masking tape purchased at a photographic supply shop.

Photographing Indoors. All the information for taking slides outdoors should be observed when taking slides indoors, but more attention has to be paid to the lighting. The camera should have a manual light meter, or a separate light meter must be used. Buy film that is suitable for use with indoor floodlights. Remember to buy the exact wattage of floodlight called for by the particular film. These floodlights are accurate for only a certain length of time, so you should turn them off

when you are not using them. Keep an estimated record of their use to maintain the quality of your slides.

It is best to take the light reading from a medium gray patch and set up the piece being photographed in place of that patch. Make sure that your own shadow is not decreasing the available light to your meter.

It is best with flat work to try to eliminate as many shadows as possible. But when photographing three-dimensional work the shadows are often needed to delineate the forms. The lighting of an environmental or performance piece often becomes part of the art work and special care with light conditions should be taken to match film speed and type.

If you are photographing glass-covered works you must position the lights and camera to eliminate any reflection from the glass. A polarizing filter could be useful here. You can obtain a special filter for your meter in order to take light readings from pictures framed with glass. If this is impossible at least make sure there are no obvious reflections when viewing the work through the lens. If any of the lights are shining in the camera itself, make sure the lens is shaded at the time of taking the shot.

Slide Selection. The same criteria that apply in selecting your portfolio should be used here. (See the following section.) Keep your slides in chronological order and separated into any different media.

Labeling Slides. Each slide should have your name, title of work, medium of work, date, size and whether the slide is a detail. It is best to type this on a label, available at any photography store, and stick it onto the frame as it is hard to write all the information legibly on a slide frame.

SELECTING THE WORK

Galleries, private dealers and agents are in business to sell art. Cooperatives often sell as well as promote art, and museums and public galleries have a responsibility to the

community to show art. None of the above necessarily has an obligation to see your work, to criticize it or to give you feedback. You must approach an organization with a specific objective, and select the work you show them to best illustrate that objective.

If you are taking your work to a place where it will be exhibited publicly, then consider the various ways it could be shown and choose work accordingly. A gallery may want to hold a few pieces to show a special collector, or it may want to include a few pieces in a group exhibition. Perhaps it has a theme show coming up into which your work fits. It may be looking for artists to give solo shows of current or retrospective work. A museum or cooperative could also be looking for artists for group or solo shows. A private dealer or agent would be more likely to want a few pieces of work that represent you. A different selection of work from your slide or art portfolio will have to be made for each different space that you visit.

Here are some things to consider when selecting your work for three kinds of situations.

1. *Short-Term Consignment.* If you are willing to leave your work on consignment for a short time, then select a few of your very best pieces.

2. *Group Show.* If you have no idea of the theme of the show or of the other members of the group, then it is best to show a wide range of your latest work. When you do know, make sure that the work will combine well with the other contributors', or if it is a theme show, with the main idea of the show. For example, a gallery may want to exhibit drawings by sculptors. A selection of slides of your best sculptures, along with a group of drawings, will tell the gallery all it needs to know.

3. *Solo Show.* If you go to a gallery seeking a solo show you should decide whether you want to show just your latest work or a retrospective. It is not necessary to show every bit of work you have ever done, but a chronological choice should

be made. The gallery may already be familiar with the scope of your work and not need to see the entire cross section of your slides. In the case of a solo show, a visit to the artist's studio is appropriate and should be forthcoming. Selecting the actual work to be displayed should be done by you and the gallery together.

PITFALL: Do remember to hold back some work. You may someday need this work as an "old age pension" as your prices rise. Also, it is a bad move psychologically to show your all and then have nothing to fall back on. A strong smaller showing is always better than a large weak one.

THE INTERVIEW

All the preparation and research leads up to this point. Interviews generally follow a set format, and it is possible to predict with a fair degree of certainty what will happen once you walk through the door.

Receptionist. This is the person who protects the gallery director from unwanted visitors. He or she has the ear of power and, treated with respect, can become a good friend. Once established in the position, the receptionist often doubles as gallery assistant.

Waiting. Frustrating delays are almost inevitable. You can expect to sit in the reception area getting more and more nervous while the work of the gallery goes on around you. This is not through any lack of courtesy but merely because selling art is what keeps the gallery alive, so the director is inclined to give that first priority.

Resume. Once in the interview, hand over the resume, along with any catalogs, brochures or press clippings. These should be in a neat folder. Your slides should number between ten

and twenty, and should be filed in a separate box in chrono-logical order. It is a good idea to bring along a cheap hand-held slide viewer, as galleries often don't have one readily available.

PITFALL: Some people prefer to store their slides in clear-plastic pages, but a slide always looks better seen through a viewer, even a hand-held one. When slides are placed in a plastic sheet the dealer tends to take a quick glance at the complete sheet and your work is not seen to its best advantage.

Showing Work. As discussed earlier, if your work is small enough to be portable, it may be possible to show the original. If not, you may want to bring along a small example to illustrate a special technique.

Discussion. This area of the interview, because it often leads into personal areas that you have been used to ex-pressing through art, may throw you off balance. The gallery director wants to get some idea what sort of person you are, and this is your first opportunity to judge whether or not you will be able to work together. The gallery person also wishes to know and understand your reasons for wishing to show and why you have chosen that particular gallery. When you walk through the door of the gallery, you must be absolutely clear in your own mind that you actually do want to show. The gallery will not want to invest a great deal of time and money if it is not certain that the artist is fully committed.

The gallery will want to know what ideas you have for showing, and you should have some suggestions ready. You may enter the gallery wanting a solo show, but if you are impressed with the gallery procedures and staff you might want to reconsider if an offer to be in a group show arises instead. Keep an open mind and watch for good opportunities.

Leaving Work. The gallery might want you to leave your slides or work. The work might be shown to a few collectors or artists for opinions, or the director might just want an opportunity to study the work more carefully. The work is not going to be offered for sale at this time. This condition is covered in receipts and contracts, which will be discussed in a later chapter. Samples are in the Appendix.

Make sure you set a date when you can pick up your samples, or else you may never see them again. This has the added advantage of getting you through the door again, which may also be a brief opportunity to show off some new work.

Interviews with museum personnel may go pretty much along the same lines as at a gallery. Obviously, there will be no talk of buyers. Museums usually have set days of the week or month when they view artists' slides or work.

An appointment with a private dealer or agent might not be so formal. He may not have a receptionist, but—if he is good at his job—he will have interruptions by collectors, museums or galleries.

An interview with a co-op might be much more varied. The work generally must be seen by the membership, and there may well be a screening committee that will see you first. They may have a set procedure and specific requirements for the type and number of slides, which you should find out about in advance.

SHOWING WORK AT YOUR STUDIO

If possible, you should always bring collectors and others interested in your work to your studio. The actual work always makes the best impression; slides are very much a second best. Being on your home ground also gives you a better chance to form an opinion of them.

If the gallery person likes what little he saw of your

work at the interview, a representative may come to your studio. This is not to be treated as a visit from royalty, and the gallery person will probably prefer to see your true working environment. Beyond your art, a clean chair and a cup of coffee are usually all that is needed.

You should select your work for this meeting very carefully. It can be organized chronologically or by theme or medium but as mentioned before, do not show too much. A strong show displayed to its best advantage will win the day.

Ideally, if framed, the work should be placed at eye level for comfortable examination. Otherwise, it should be stacked or displayed in one area of the studio. And the work need not be framed for a trained gallery person to be able to visualize its effect.

After a show has been arranged, the dealer may want to return to your studio to make a selection of work. You may want to remove some of the work you wish to retain for your own collection and then leave him to familiarize himself thoroughly with your art. He, or she, may make a selection which will fit the gallery space and then you can have final say on whether you agree with the choices. At this point a compromise will probably have to be made between your subjective view of your strongest work and his more objective view of what will be appropriate for the space and what might sell.

CHAPTER 6

the collector

Aside from the casual art buyer, there are probably fewer than three thousand serious collectors of contemporary art in the world. This figure does not, however, include dealers, museum curators, art critics, the government (through the National Endowment), businesses, art councils or artists themselves. Jasper Johns and Donald Judd, among contemporary artists, are renowned for their collections.

MOTIVES

The motives of art collectors can usually be ascribed to one or more of the following categories.

Aesthetics

Like the magpie, the human race has a basic need to collect and surround itself with attractive things. Some people, instead of choosing cars or clothes, select art for that purpose. The sheer enjoyment obtained from a work of art is sufficient reason for their spending thousands of dollars. The example of the serious collector who buys good stolen art simply for

the pleasure of enjoying the work—whatever the risk—is often quoted in this context.

Immortality

Philip Johnson, who has his own private museum, maintains that "what drives people is not hunger or sex, as Freud says, but immortality."

Art is readily available to the wealthy as a memorial to their financial success. Some of the great collections have been formed as a tribute to this particular vanity, including those of Catherine the Great, Guggenheim, Hirshhorn and Mellon. Although in most cases individuals choose to be remembered with a collection named after them, others, such as Joseph Hirshhorn who has his own private museum on the same street as the White House, prefer a more egotistical approach.

Social Advancement

Art has often been the medium through which successful businessmen or status-conscious people have sought to acquire respectability. Large collections in this category are often bought more with money than with taste and reflect the lack of knowledge of the buyer. William Randolph Hearst's collection in San Simeon, California, for example, contains under the same roof art from virtually all periods in history with little concern for good taste. For the very wealthy, the acquisition of art can be a relatively small part of the discretionary capital, though the expenditure may go into the hundreds of thousands of dollars. Hirshhorn, for example, maintained that he "buys art like other people buy neckties."

Investment

Some people favor diamonds or stocks as a hedge against inflation, but art experts believe it is their business, with a billion-dollar annual turnover, that represents one of the best investments available. Banks, mutual funds and foreign investors increasingly agree with that philosophy, and private

collectors are now commonly joined in their pursuits by the institutional investor.

Today, in terms of money invested in art, the private collector is the exception. The largest sales of art are to other dealers, mutual funds, Swiss banks or corporations.

According to Robin Duthy, publisher of the private-subscription *Alternative Investment Report,* twenty years ago those who talked about collections rising in value risked being labeled miserly, mercenary or vulgar.

Duthy points out that a desk designed by the Art Nouveau architect Charles Rennie Mackintosh was sold in 1933 for $20 and in 1979 for $180,000. Italian paintings of the fourteenth century could be picked up a hundred years ago for a few dollars; they are now worth tens or hundreds of thousands.

One example of the big institutional involvement in art is illustrated by the giant banking group Citicorp. With the cooperation of Sotheby Parke Bernet Galleries in New York, Citicorp is drawing the attention of its clients to high-quality art objects that have appeared on the market.

The scheme, which began in September 1979, involves Sotheby's advising on the quality, history, condition and likely value of pieces that are on the international market. Citicorp's own experts talk to investors. Those wanting to take part in the scheme have to have at least ten million dollars invested with the bank and be prepared to spend around one million dollars of that on antiques and works of art.

Citicorp is paid 2 percent of the cost of each purchase and 2 percent a year of the individual's portfolio value; and fees are paid to Sotheby's every year for valuation.

The injection of huge sums by Citicorp and others is bound to add to the inflationary spiral in the art market, particularly as the institutional buyers are very likely to withdraw their purchases from general circulation—conscious as they are of the high cost of security and insurance.

There are other reasons why the situation has changed drastically in the last five years.

John Richardson who is associated with Artemis, the international group of dealers, and the Knoedler Gallery in New York has said, "Today, the private collector is the exception. Our largest sales are to other dealers, mutual funds, Swiss banks, Japanese corporations. You don't have real collections any more. What you have are bank vault holdings.

"Soon all the best art and antiques will be locked up in bank vaults for capital appreciation and there will be nothing left to buy."

Aside from the obvious costs of security and insurance, there are other reasons why a lot of great art is being steadily withdrawn from circulation. First, overexposure can often be detrimental to the price of a work if it is meant to be seen exclusively as an investment.

Also, when the time comes to sell a work, it is easier to impress the potential buyers with one that has been off the market and out of sight for many years. And a sale will be choreographed with as few people brought in as possible. Although it is helpful for a work to be viewed in a museum show to establish it as absolutely bona fide, great care must be taken that the work not be considered for sale. Doubts could easily be raised in the buyer's mind about quality and provenance if the work remains unsold for too long.

To meet the specialized demands of the investor, various companies have been set up to view art specifically as a commodity. Through an analysis of profit margins, balance sheets and market research and with the help of art experts, they hope to provide a worthwhile return for their investors.

It is instructive to quote a section from a recent annual report of one of these companies, Artemis, which has an authorized share capital of ten million dollars and is based in Luxembourg. Included on the Board of Directors are Baron Lambert, Count Artur Strachwitz and Mr. Walter Bareiss.

"Foreseeing that the art market might be entering a period of uncertainty, we have since last autumn diversified

our buying on the assumption that if one aspect declines, another may expand.

"At the same time, we have continued to buy paintings by artists whom we believe to be immune to changes in fashion. For reasons which we have explained in previous reports, with apologies, many of these acquisitions cannot yet be published. Sellers seldom wish it known that they have sold, and buyers—particularly museums—often prefer to be the first to publish what are for them their own discoveries. Although we should like to illustrate all our finest works of art, to do so would in many cases forfeit us the confidence of the very people essential to our success—buyers, sellers and business associates."

Another company, which operates on similar lines to Artemis, was called Modarco and was formed by a number of international bankers and industrialists who speculate on the value of first-rate art.

Modarco now owned by Knoedler deals in such artists as Alexander Calder, Josef Albers, Paul Klee, Fernand Léger, Pablo Picasso, Henry Moore, Andy Warhol and Jackson Pollock. Their thirty-million-dollar inventory is kept in a warehouse in Geneva.

Switzerland, that most accommodating of nations, has a special customs area set aside so that works of art can be exchanged between buyers from different countries without their ever having to leave the top-security vault.

The trend for promoting investment in art is gaining momentum, and galleries are being forced to join the movement as it represents a substantial proportion of the money invested in art annually.

One company brochure offers clients six different plans for investing one hundred thousand dollars or more in original art from the Impressionist period on. A German publication even publishes annually a list of the top one hundred artists, in terms of financial appreciation.

Behind most new investment companies are the banks, which lend the money necessary. Although accustomed to dealing with millions of dollars in art financing, the nation's banks are trying to cash in on what they have discovered is a lucrative and relatively risk-free loan area.

Most of the loans made to individuals for the purchase of art objects range from two thousand dollars to one hundred thousand dollars, carry interest rates of between 11 and 12 percent, average two years in length and are paid off in monthly installments.

This has one beneficial side effect for artist. Banks have found that artists, and in particular sculptors, make a reasonable credit risk given that the cost of materials is often considerably less than the final selling price of the work.

Another of the ways in which the art market has changed in financial terms is with mutual funds. Cashing in on the Arab oil money, the Middle East Fine Art Investment Company was formed in 1975 with capital of twenty-five million dollars. Shareholders subscribed a minimum of ten thousand dollars in the pursuit of a healthy return on their investment. All the money is spent on purchasing Middle Eastern antiquities and holding them until they show a capital appreciation.

The British Rail Pension Fund, a very conservative institution, has invested thirty million dollars in fine art. Exactly what art it owns, and how much has been paid for it, is largely kept secret.

The Fund managers argue that they have purchased pieces from all over the world to make up selected collections and, if people were to know exactly what pieces were needed to complete those collections, the price for the pieces would go up. A logical argument, but one that ensures that many of the works will never be seen until they are sold again.

While the less expensive art is becoming more readily accessible to almost everyone, there is no doubt that the expensive works and the finest examples of a school are gradu-

ally disappearing as art reaches new heights of commercialism. While there are certainly more museums than ever before, a finite number of master works exist. As these are hoarded away, they become increasingly withdrawn from public view.

AUCTIONS

"Let me entreat you, ladies and gentlemen; permit me to put this inestimable piece of elegance under your protection; only observe that the inexhaustible munificence of your superlatively candid generosity must harmonize with the refulgent brilliancy of this little jewel."

When he completed the sale of a work, James Christie would say to the buyer, "It is yours, Sir. I give you joy."

Such a courtly approach to auctioneering died out a very long time ago. It has been replaced by a very businesslike —and very successful—approach, which has carried the major auction houses of the world into the forefront of the art business. Auctions now account for some 50 percent of all sales of art during the course of a year.

Like any other method of selling your work, auctions can be fraught with difficulties unless you are adequately prepared.

The factors that combine to determine the price paid for a painting or other work of art at auction range from such major points as the reputation and standing of the artist to such trivial things as the weather on the day of the sale. Between the two lie many other reasons—aesthetic, scientific, philosophic, geographic and economic. Young and unknown artists will find no benefit from auctioning their art, but may one day find knowledge of the process useful.

There are several basic steps to follow if you are planning to auction your work. And if a work of yours comes up for sale at auction and you are interested in repurchasing it, the information on bidding will also be of concern to you.

Estimates. Although the auction house will probably have

its own experts to provide you with a valuation, it is advisable to get your own estimates, preferably from several different sources. The tales told of bad valuations by even the most reputable auctioneers are legion. For example, a recent sale of modern paintings by Sotheby Parke Bernet that was expected to fetch seven million dollars raised only four million seven hundred fifty thousand. Again, a sale at Christie's in London of leading Impressionists resulted in only eight of the fourteen paintings topping the reserve price and being sold.

Reserve. Once both you and the auction house have agreed upon an estimated sale price for the work, you will put a reserve on it. The work must then reach its reserve price in order to sell. If the work fails to find a buyer, the term used by the auctioneer is that it is "bought in," which simply means that it did not sell.

Commission. All auction houses charge a percentage commission, which usually starts at 10 percent and reduces on a sliding scale as the value of the work being sold increases. The commission is levied on the seller. If a work fails to reach its reserve, a smaller commission is still charged.

Sotheby Parke Bernet recently introduced a commission chargeable to the buyer as well. Although this was greeted with outrage by the art world, Christie's have been operating a similar scheme for years. They have been conducting the bidding in the monetary unit of guineas, which are worth 5 percent more than pounds. Thus every buyer has effectively been paying a 5 percent commission.

Catalogs. These are used to advertise the sale. Usually they give quite a bit of information about the work being auctioned.

If the full name of the artist is listed, it means that the work is definitely by that artist. The initial and last name indicate that it is thought to be by that artist. Last name only means it is in the school of the artist.

Various aspects of the work are noted, including the provenance or history, the seller (if well known), the year

of creation, the medium, the size, whether it is framed or unframed and the edition, if it is a multiple.

A list of estimates for each work is published and included with the catalog. These estimates are determined by the auction house, and although they may give a clue to the reserve prices, those figures are not made available. After the auction, a list is published stating the prices the works were sold for. The listing will not include the works that didn't sell.

Once a year the auction records are published. These become an excellent guide for sellers in tracing the rise and fall of prices.

Bids. The bidding is not started at the reserve price but somewhere below it in order to create an atmosphere of tension and enthusiasm. If the buyer cannot attend, bids can be taken by mail or by telephone. These bids are often used to raise the bidding in a controlled manner.

It is also possible to commission someone to buy at an auction for you. In this way, you might pay a little less by having someone on the spot who can sense the mood of the sale room and bid accordingly.

Auction Rings. These are illegal, but seem to occur fairly frequently in different parts of the world. A group of dealers or (with less frequency) private collectors may be bidding jointly for the same work and will agree to let just one person do the bidding, thus eliminating unnecessary—and expensive—competition. They then draw lots to see who gets the work, or they may bid in turns. Another scheme is to split the cost of the work and divide the profit when the work is resold.

CHAPTER 7

pricing

It is generally incomprehensible to most artists that huge sums can be achieved for certain well-known artists while not even a living allowance is possible to most others.

Jackson Pollock's *Blue Poles* was sold for six thousand dollars in 1956, the year of his death, and by 1973 it had been sold to the Australian Museum for two million dollars—three hundred and thirty-three times the original price. Projecting similar continued increases, by 1996 the painting, if it came on the market again, could change hands at a billion dollars—an increase of 50,000 percent.

While such rapid price changes appear at first glance to be quite ridiculous and at times very unfair, there are certain concrete reasons for them.

At the first World Art Market Conference held in October 1976, the dealers confirmed that they assume responsibility for setting prices, adding, "The rules are, there are no rules."

The dealers have their reasons for wishing to maintain the mystique of pricing. For instance, a dealer may not want a collector to know what commission or profit he is making on a work for fear of appearing greedy. The price a collector

pays is often confidential and not known to wife or taxman. The knowledge of pricing gives a dealer a certain power over the artist as well, particularly if the artist is uninformed.

The gallery does have expert day-to-day knowledge of what price the market can stand, and it is generally in the artist's best interests to listen carefully to what the dealer has to say on the subject. After all, the gallery is going to have to sell your work. It has to believe the price it is asking is an amount the collector is prepared to pay.

It is possible, however, to set forth some guidelines that will help an artist understand how the dealers arrive at a price. If these guidelines are followed, the artist should have a fair idea of what is a reasonable price for his work. He can also ensure that no work is sold for less than the cost of the materials, or priced so high that it is never sold. And the more prestigious an artist is, of course, the more he can command his own prices.

The pricing of your work is determined by four main factors: demand, your expenses, the quality and the scarcity of the work. Each of the four factors influences the pricing to a different extent for each artist. To help establish the initial pricing of your work and to estimate how your prices may grow, it is important to understand all these factors.

Later, when your work has sold and resold and attains the reputation of a sound investment, there are other factors that influence the pricing. Learn now what these further refinements in pricing are and how they could influence your future market.

The simplest way to get an early idea of what the market will stand is to compare the price that works similar to your own are bringing. To do that you must very carefully estimate the reputation of the other artist and the dealer, the cost recovery, and the quality and scarcity of the work.

Ultimately, of course, since it is very difficult to find another artist who matches you in all the categories outlined, comparisions are not going to provide an absolute answer.

The information in the following sections, however, can serve as a guide for comparisons to help in arriving at a fair price for your work.

REPUTATION

Artist. An artist's reputation ultimately rests with the quality of his work, and those considered best qualified to judge his work are his peers. The entire art world takes its lead from the opinions of the artists themselves.

Dealer. The seller's reputation is quite as important in the pricing of a work as the artist's. It is the combination of the two that the buying public considers.

Collector. When a work is sold to a collector, the actual price paid becomes the current market value. Therefore, the importance and number of collectors you and your dealer have sold to is a regulating factor in pricing. Certain collectors are often invited to view new work before it is put on view for the general public.

Museum. A dealer has to be able to get the attention of museums, trustees (who are often collectors) and curators (who generally decide on the content of forthcoming museum shows). An artist, in turn, is judged by the prestige of the museum where his work has been either shown or actually purchased. Often, work is sold to a museum or important collector at a discount, because of the prestige gained by the sale.

Critical Reviews. A dealer needs a definite flair to attract the attention of the media and the critics. If the artist has received a critical review, the stature of the critic is as important as whether the review was favorable or not. Critical reviews do not sell art, but they do build an artist's reputation, and it is important to see just what effect a critic can have.

The critic praises art he or she believes in, but can also be paid by a gallery to write a review of a certain artist or

show. The publications the critic works for may run these reviews because they want to use, without additional expense, the gallery's color plates, which give their magazine a quality look.

The critic has been known to accept gifts of works of art from artists before or after a favorable review.

During the abstract expressionist period, art critic Clement Greenberg suggested that to achieve any degree of purity in style, the painting must be "flat," that is, not violate the integrity of the picture plane. The subject became an obsession among many artists at the time. The important thing to realize was that the critic did not write about a movement already in existence, but rather, the work followed the theoretical writing.

It is also interesting to note that Jackson Pollock began painting to fit the flatness theory and it was Greenberg who discovered him. It was on Greenberg's reputation as a critic that Pollock's reputation as an artist was built. (Of course, once Pollock was an established star, Greenberg's theory was proved correct.)

Juried Shows. Obviously, getting accepted into a juried show and winning a prize are accolades. However, it is also important to take into account the nature of the show and the stature of the jury. The members often include dealers, museum personnel and collectors as well as critics. Acceptance into a quality juried show is another good step in the advancement of your reputation.

Solo and Group Shows. A solo show or a group show, either with people of a higher reputation than yours or with a school of work with which you could be associated, can enhance your reputation, provided it takes place at the right gallery or museum.

Commissioned Work. Dealers quite often get commissioned work for artists. Of such commissions, the public ones will be more widely seen and noticed than those of a private patron,

but the grapevine among patrons for private commissions, along which news spreads rapidly, can also help build an artist's reputation.

International. All the above information becomes even more important when applied on an international scale. A museum show at the Tate or the Beaubourg Center not only will establish an international reputation but is prestigious in the United States as well. And by the same token, shows at MOMA, the Whitney or the Guggenheim certainly carry much prestige in Europe. Establishing a reputation abroad could certainly be aided by participating in the International Art Fairs.

COST

Enthusiasm for making a sale should not blind the artist to the fact that there are certain costs incurred in creating a work of art, which must be recovered when the work is sold. Selling a work is, after all, a business, and no business ever plans to run at a deficit.

It is important to keep a record of all costs as they are incurred. This is not simply a matter of the price of a canvas and some paint, but includes other costs to the artist incurred in the process of achieving the finished product.

Materials. The cost of all materials used in the making of a work of art must be included in the sale price.

PITFALL: Please note that your labor costs are your first expense and if you are successful will ultimately be covered by your profit. Your own labor, however, can never be used as a tax deduction. (More on these in Chapter 10.)

Labor. All labor costs, including that of the artist, should be noted. Personal labor may sometimes be difficult to price,

but any money paid to assistants or helpers should be on record. Unfortunately, it often works out that even though a work sells for fifteen thousand dollars, the artist is only paying himself a dollar twenty-five per hour for the time spent on the work.

Overhead. The cost of running any machinery and what you spent on electricity, insurance, rent and any other items related to producing the work ought to be included in its price.

Inventory Cost. Year by year, because inflation, material, labor and general overhead, costs do rise. Unsold works that the artist keeps in stock ought to have an allowance put on them every year to compensate for inflation. Figure the increase by estimating how much more it might cost you to create the work at the current time.

Promotion Cost. This includes the gallery's or dealer's commission. It also includes the cost of any advertising or promotional material related to the sale of your work. No work should ever be sold below the gallery price except for the allowed discounts to museums, collectors or other dealers.

Handling Cost. This includes the costs of framing, crating and shipping a work to another area.

Profit. Many artists, even those who are very professional, must support their work and do so in a variety of ways. As prices rise, the profit should also increase.

QUALITY

Materials. The use of high-quality materials is as important to your conception of your piece as it is to the longevity of the work. Inferior materials will certainly not help to increase the price of your work.

Technique. Although one particular technique will not get a higher price than another, an extremely complicated production might well gain a higher price in the market. Shoddy craftsmanship will always be a handicap.

SCARCITY

All artists do not work at the same speed or produce the same number of works per year. Such variation causes the market to look with different eyes on very similar works and contributes to wide variations in price.

Production Rate. Some artists may manage only one work a year, others may produce fifteen. If there is equal demand, an artist can expect a lower average price for his work if he produces five times as many pieces as the next person.

Demand. Steady demand for work of limited supply will inevitably push the price up. It is possible that the demand may be limited to one particular area of an artist's work. This will push the price up in that particular area while the prices for other works can remain fairly stable.

Posterity. When Vermeer died he left only thirty-two completed works for posterity. This was the dealer's dream of absolute control. Every picture has been thoroughly cataloged, and a good dealer in old masters knows where all thirty-two can be located. The prices will continue to rise every time they change hands. When an artist is dead, the number of works becomes finite and they achieve a scarcity value, that is, the value of a limited quantity. David Smith and Mark Rothko died leaving many more works but the same rule has applied.

REFINED PRICING

There is a broad range of conditions considered by both collector and dealer in setting a market price. Some of them relate to the long-term requirements for a superior work. Others are more difficult to pin down and are often influenced by current vogues and fancies. The following are some of those considerations.

Type. If a work by an artist is highly representative of his style, it is liable to be more in demand. Who, after all, wants a Matisse that looks like a Courbet? A certain

period, or several periods, of an artist's life can also be especially sought after.

School. Often an artist is associated with a particular movement in art, and his work can rise in value because of that association. For example, when the great Impressionist works were being rapidly sold, the second string of less-well-known Impressionists experienced a price rise as well.

PITFALL: During a recession, when many people sell out, it is the second-string and poorer-quality works that don't hold their values. Knowledge of that fact can make the buying public very nervous.

Subject and Size. No artist should ever depict a specific subject or produce a certain size of work because it might more easily be sold. Nothing, however, can keep vogue from dictating what is fashion in this respect. Happily, as in every passing phase, there are always unusual collectors who make their own way. Also, a work might be of particular interest to a collector and he will be willing to pay a higher price for it. For instance, one collector buys only black and white prints that are self-portraits.

Condition. How well you construct your piece really does matter. It must withstand shipping, crating and regular exposure under hot lights. It must simply be made to last a long time. Paintings are classified as "prime," "good," "damaged" and "overcleaned." The price varies depending on which classification is applied to your work. Even earth works and conceptual pieces have photographs, films, manifestos, all of which must be maintained and preserved. Full details of materials used to produce the work, which either are stated on the artwork or accompany it through its life, will be one major factor in keeping its condition "prime." Otherwise, most of the control of the condition of the work passes out

of your hands when the work does. Obviously, the work you keep should be stored and shown under proper conditions.

Authenticity. A dealer once pointed out to Salvador Dali that one of the works in a new solo show had been stolen. Much to his embarrassment, Dali had to admit that he had bought the work without checking its provenance or history.

The more detailed a work's history, the more assured the collector will be that he is buying the genuine article. He will also be likely to pay for that security. Not only should a certificate of authenticity accompany every work (an example of one is in the Appendix), but the artist must also keep a thorough listing of a work's show record. Details of any exhibitions where a work has been shown along with names, dates and notations of illustrations made to display your work in a catalog or review should be recorded. If you make a list of when your work has been shown and keep track of any resales, it will be much easier to assess its current market price.

Signature. Do remember to sign and date all your works. A work "in the manner of," "in the school of" or "in the studio of" never realizes the same price as a signed work.

Person, Place, Time. If the reputation of the dealer, collector or museum that is selling the work is great, the price can be raised. Investment companies have gotten wise to this trick and have started buying what would consist of an entire museum exhibition. After offering it to the museum and having it duly shown, the works are put back on the market at a healthy markup.

A good dealer will offer work in the right place, be it a specific gallery specializing in a particular type of work or a country in the world where demand may be higher. He will also know when the best time for this sale would be. This art buying season is in the spring and fall, with a good short

season at the end of June in Europe, the season of the auctions and art fairs.

Strangely enough, prices usually drop right after an artist dies because the public becomes aware and digs out all work by that artist that it may not want from attics and spare bedrooms. Such works and special retrospective shows can flood the market. The scarcity market which should be created because of the halt of creation is temporarily overcome by the sudden quantity of work available.

Auction. Prices at auction can be uncertain even at the best of times. An event completely unconnected with the auction itself, such as a heavy thunderstorm, might keep just the right buyer at home. A very conscientious dealer may go to an auction whenever one of his artists' works comes up for sale, in order to protect the price. He will do this by bidding for the work until it has reached the price it is currently being sold for at the gallery. This is against auction policies, however, and it is considered unscrupulous when dealers, and even artists, use the auctions to create artificially high prices for work.

THE FRENCH POINT SYSTEM

The French have devised a system to work out the price of any given painting by any given artist. A point value is assigned to each artist depending on his reputation in the art world. The possible sizes and subject matters a painting can have are given other point values. The price of a work is then determined by multiplying an artist's point value by the size-and-subject-matter point value. For example, your own point value might be one hundred (or one hundred dollars). A landscape of medium size would be five points for all artists. Multiply five by one hundred, and your medium-size landscape would sell for five hundred dollars.

This system eliminates a lot of arguments and might

make international marketing much less complicated, but it does not take into account varied qualities, reputations and demands. It is not used in the United States, but is in some French-associated galleries throughout the world. The system is not the only one used even in France, but it does have widespread use for a medium price range of French artists for which the market is very broad.

THE WORLD VIEW

The art market is affected by world prices in other trades. A good economic climate will generally mean higher prices for art, while the reverse applies in a time of recession. High-quality art retains its value at all times, which is why it is such a good investment, but lesser and little-known works can actually fall in price.

Heavy buying by the Japanese in the late sixties shot the prices for Impressionist paintings sky high. As the Japanese curbed their spending, several minor Impressionist works were impossible to sell. They were often relegated to the back of gallery storage. Eventully they will reappear when inflation and scarcity have made their prices credible once more.

The same sort of thing happened in England in the mid-sixties. Several of the artists who rode the wave of success during the boom for contemporary art are now little known. Their works can be purchased at auction for very little as they slowly reappear on the market.

BE ORGANIZED

In our discussion of pricing, we cannot overemphasize the value to the artist of an organized structure for setting prices that is established early in a career. Whatever prices you start with—your first sale might be a still life that you sell very reasonably to a relative—they should rise over the

years in a steady and careful fashion. This will help protect you from the speculators and should give you a reputation of reliability, which will encourage genuine collectors.

Gerald Laing had built himself a good reputation as a sculptor in the United States and Europe in the 1960s. As one of the new group of artists, his work was widely collected and prices rose steadily. In the early 1970s he bought a small castle in Scotland and renovated it and dropped out of the art-market world almost completely.

During this time some of his works started reentering the market. Because he was no longer being shown or promoted, the prices for his work fell drastically. It is only now, after returning to the United States, that he has slowly managed to rebuild his shattered reputation. He has had to find new galleries and reestablish confidence among his collectors, who were very disappointed at what had happened to their earlier investment in Laing's work.

Every year you should reevaluate your prices with your dealer, especially before a new showing of work. The market must be able to bear the prices you set. Raising the prices too sharply can mean disaster if, when the work is resold, the same price cannot be met. This will undermine the confidence of collectors. If your prices stay constant for too long, your work will not be thought of as a good investment—even against inflation—and you will certainly lose some sales.

CHAPTER 8

receipts, agreements and contracts

A gallery can agree to purchase an artist's work outright, but it is more common for a dealer to act as a selling agent. This arrangement can take a number of different forms and each of them has its own peculiar brand of problems. Whatever the ultimate arrangement, the dealer remains responsible under the law for carrying out the wishes of the artist and not, as is generally thought, the other way around.

Dealers are fairly reluctant to put their commitments in writing (indeed, most of the dealers we have talked to would positively refuse to do so), and often you will not be in a position to force the issue. However, if you have made it clear that you know the law and the dealer's responsibilities under it, there will be much less chance of a subsequent breakdown in the relationship.

RECEIPTS FOR WORKS LEFT ON CONSIGNMENT

The first and perhaps most common method of getting established in a gallery is to leave works on consignment. The dealer simply agrees to do his best to sell the work during the time you have agreed to leave it with him.

In the event that a gallery goes bankrupt or the owner dies, the Uniform Commercial Code specifies that all works on consignment remain the property of the artist until he has been paid for them in full.

When leaving works, *always* get a receipt. Tales of works being left on consignment and never seen again are all too frequent. A receipt should help prevent that, provided the following items are noted.

Date. When the works were left on consignment.

Date of Work's Return. The date set for the end of the agreement. This should be followed up to make sure that everything is progressing smoothly and that the work will be ready for collection on the arranged date. The shorter the period of the agreement, the safer the work will be.

PITFALL: If you leave a work for a long time, chances are far greater that it will be lost or at least damaged.

Details of Artist and Gallery. These must include name, address and telephone number of both parties.

List of Works. Details of the work's title, the materials used, its dimensions and the date of execution.

Price Agreed On. See Chapter 7 for suggestions on how to arrive at prices.

Commission. The commission to be taken by the gallery in case of sale of the work must be agreed upon in advance. For consignment, this will range between 10 and 50 percent. Ten percent will be charged by charities and other philanthropic bodies.

Insurance. While most galleries carry insurance of one kind or another, it is very seldom for the full value of the artist's works. Most galleries insure to 40 to 60 percent of value, with a very few insuring for 100 percent. While it is not necessary for the full value to be insured (if your work

goes up in flames, you hardly have to pay a commission to the dealer), it is important to find out how much you will get paid if the work is lost. This amount should be no less than and probably more than the amount you would have received had it been sold normally, thus taking into account its future investment value.

Payment Time. This should generally be thirty days from the time the work is sold, but collectors are notoriously slow payers. To make sure you receive payment, you must check regularly with the gallery to find out if any work has been bought.

PITFALL: This is open to abuse as no one but the dealer knows when a work has been sold and at what price. Sales are sometimes postdated.

Discounts. The artist must agree to the percentage of any discounts given by the gallery to other dealers and museums. This is generally 10 percent and might even be extended to important private collectors and museums.

If the gallery fails to provide a complete written receipt, write a letter on your own stationery outlining the details of your conversation with the gallery. Keep a copy for your records and mail the other to the gallery. Then if anything goes wrong, you at least have a record, made while the conversation was still in your mind, of the deal.

AGREEMENTS ABOUT SHOWS

This section applies particularly to a solo or group show, or to any other situation when works are being displayed for a strictly limited period.

There is really no set rule about who is responsible for various expenses related to shows, so the points listed below are for the most part subject to negotiation.

All issues covered by a consignment receipt should also be covered in agreements made regarding shows.

Date. The date when you are to supply the work to the gallery must be specified, along with the exact dates for the show. Generally, the gallery will require the works sometime in advance, and you can expect to have the unsold work returned within a month of the end of the show. Works should not be removed during the course of a planned exhibition for any but the most serious of reasons.

PITFALL: Artists have been known to remove works during a show for political, personal or even economic reasons, as a protest against the gallery. This is extremely bad for the artist's reputation, but you really have to follow your own conscience at such times.

Commission. For solo shows this is generally between 40 and 60 percent. For group shows, it can be as low as 20 percent or as high as 50 percent. The exact figure is a matter for negotiation but must be agreed upon in advance. The expected costs for such things as publicity, advertising, invitations, posters, postage, opening parties, framing and transportation, and which party is to bear those expenses, all affect the rate of commission.

PITFALL: Publicity is a large part of the promotion, but should the dealer want to give away a work of art free to a prestigious collector, critic or museum, you must be compensated.

Publicity. A gallery usually has its own schedule for handling the publicity and getting in touch with the newspapers and other media to let them know about the show.

This could entail such expenses such as press releases or lunches for critics. The artist should be aware of which party will cover these costs.

Advertising. It should be agreed on where the show is to be advertised and by what method. All galleries have their own advertising budgets, and you want to find out if the allowance is adequate. If not, you must decide if you can afford to contribute the difference. Also find out who will be supplying the photographs for color plates, who pays for them and who retains ownership.

Credit Risks. The gallery must take the responsibility for all credit risks. If, for example, a picture is released to a collector and the check subsequently bounces, the artist should still receive his sale price for the work, or have the work returned. Check to be sure it's in the same condition as when it left the gallery.

Price Fixing. The artist will have to agree not to sell any work privately for less than the gallery price agreed upon. You would not, after all, want to threaten your established market price. Remember that the gallery is due its commission on any work sold from the artist's studio during the course of the show.

PITFALL: If you do hand over the mailing list, try to use it as a bargaining tool. The gallery will add your list permanently to its own, possibly taking some of your future sales for other artists.

Invitations, Postage. You may have strong views as to whom you would like to have included on the invitation list. If the artist wishes to send his own mailing list, he must make sure to recover the cost of the postage if that has been agreed. Otherwise, turn the mailing list over to the gallery.

Crating and Transportation. It is generally accepted that if the artist is local and the works are small, the artist should deliver the work to the gallery. If the show is out of town, then it must be established who is going to pay the shipping bill. If it is decided that the artist is to pay for the crating, make sure the dealer keeps the crate for the return journey. There might also be special transport insurance. If all the above is not agreed to, you may receive the returned work C.O.D. or not at all.

Framing. The gallery has a number of options with regard to framing. It may have some frames in stock. It may want to buy special frames and keep them, or it may want to sell you some frames. The gallery may recommend that the artist frame all the works before delivery to the gallery. In that case, a sum should be added to the artist's sale price so that the cost of the frames can be recovered.

The type of frame to be used should also be established in the agreement. You may not wish to have a gilt Victorian frame around your hard-edge abstraction.

Catalog. This is sometimes included in the gallery's budget, but if you have strong views about the content or design—the color reproduction or artist's statements, for instance—let them be known well in advance.

It is a common complaint among artists that catalogs are often not ready in time for the opening. Make certain the gallery has brochures and catalogs on hand.

Also make sure about ownership of the color plates used for advertising.

CONTRACTS WITH DEALERS

A formal contract is often advisable if a dealer decides to represent an artist, meaning the artist agrees to allow the dealer to act as his selling agent. In such an arrangement, it is very much in the interests of the artist to spell out exactly

what is involved in the relationship, making sure to cover all the following issues (and they are numerous).

All the issues raised in the two preceding sections apply here and should be discussed.

Duration. The contract needs to be made out for a specific period of time. Three years is a fairly common arrangement, but any period that suits both parties is appropriate. The artist may wish to have the agreement reviewed every year.

There must be a clause giving either side the right to withdraw from the contract. Sixty to ninety days' notice is usual. However, considerable annoyance can be caused to a gallery when the date of notice allows the artist to withdraw immediately before a show that may have been planned months in advance. It is best to plan ahead to avoid such a situation.

Limitation Clauses. The contract will usually give the dealer exclusive rights to represent the artist in a particular geographical area. If the artist wishes to reserve some rights of his own, then that should be spelled out. For example, the artist may have some particularly good contacts in Kansas City and want to exclude that area from the agreement.

He may also wish to exclude some commissioned work, such as portraits.

It should be made clear whether the gallery will be promoting you worldwide, and if not, which countries you are free to approach.

Commission. The amount generally charged by a gallery is in the same range as that for a solo show, that is, 40 to 60 percent. However, if the gallery handles the sale of a large number of works to an investment company, it may arrange for a very advantageous discount to the company, even to the extent of the artist's agreeing to accept as little as 30 percent of the original price. Such sales generally require contracts of their own.

Show Frequency. The artists in a gallery's stable are shown in rotation. If you work very slowly, you can't expect to be

shown until you have enough work available. The object is to have your work shown on a regular basis.

PITFALL: Even if you create entire shows every two months, you should not show that frequently. A dealer might be able to push your prices up for one or two years on that basis, but it would be a weak base, and open to speculators and fluctuation.

Juried Shows. If the artist lives out of town, he may want the gallery to handle entries into juried shows. On the other hand, the artist may want to discuss the matter of each show with the dealer, or handle it entirely on his own. (For further information on juried shows, see Chapter 4.)

Leasing Work. Some organizations would rather rent art than buy it outright, as renting can have certain tax advantages. If the artist agrees to let the work be rented, then the prices and rental period must be agreed upon.

Advances. Some galleries are prepared to tide an artist over in a difficult financial period. This is done by a dealer's making a cash advance, usually in the form of a monthly allowance. In accepting the allowance, the artist generally agrees that the loan must be paid back out of income from expected sales. If, however, the sales fail to materialize, the artist could have a clause in the agreement whereby the dealer may buy the equivalent value of the loan in paintings so that the artist can repay the loan.

Some artists prefer cash advances or a monthly income plus credit on art supplies as a way of regulating life and having a steady income.

If a dealer is prepared to make an advance, he might raise the commission charged to the artist. Under those circumstances, it can be a very expensive method of borrowing money, and if regular sales are made, should be reviewed.

PITFALL: A really unscrupulous dealer might inform an artist that there have been no sales. The artist might then agree to turn over to the dealer certain works to pay back the advance. The dealer could have pre-arranged with clients to sell those works at a greater private profit. To help avoid this, negotiate as to which specific works are going to be exchanged at the time of the "advance" settlement. This takes some of the temptation away from the sinner.

Accounts. Arrangements should be made for the gallery to supply a statement of account every three months or so to enable the artist to keep track of monies owed and works sold. Individual galleries have different methods and some will supply accounts monthly while others will only send an account when a sale has been made.

Whatever is agreed on, the artist or the artist's accountant has the right under common law to inspect the gallery's account books in relation to his particular work at any time.

PITFALL: Do not expect to march into a gallery demanding to see the books and maintain any sort of working relationship. If it becomes necessary to check records, your accountant should contact the gallery and make arrangements to see your specific accounts. The utmost diplomacy must be observed if you wish to stay with the gallery.

Credit for Clients. If the dealer wishes to allow his buyers to have private credit facilities, the artist may wish either to negotiate participation in the credit arrangements or to take immediate payment of the full sum from the dealer.

Reproduction Rights. Rights are generally reserved by the artist, and the contract should say so. However, for a realistic sum, the artist may wish to sell limited reproduction rights to or through a dealer. For example, a company may wish to buy the rights to a particular work for advertising purposes. This, however, would be subject to different negotiations outside the direct terms of the contract.

Price Reviewing. There must be a provision for fairly regular reviews of the prices set for the works to keep pace with inflation and market demand.

Returns. In the event of a purchaser returning a work, the dealer may allow the collector to exchange it for another work of comparable or increased value by the same artist. If, however, the collector exchanges the work for one by a different artist, then the dealer becomes the owner of the original work and is generally allowed to exchange it for one comparably priced.

Ownership of Work. Even if the work is on gallery premises and the artist is under contract to the gallery, the work remains at all times the property of the artist. This applies until the artist has been paid in full for the work. Similarly, work left with a gallery may not be used by the gallery as collateral for a loan. This is very important. In the event of a gallery going bankrupt or the owner dying, your work should not be included as part of the assets of the gallery.

Auctions. If an artist's work comes up at auction, a dealer will often wish to enter into the bidding to make sure that it is not sold for less than the current gallery asking price. It is in the artist's interest to see that this is done as it keeps the price for his work at a consistently high level.

It is generally recognized that this happens in auction houses. The procedure entails sending two representatives of the gallery to bid against each other, if necessary, to raise the price to a predetermined level. While this is highly illegal, it does happen.

Artistic Control. There may be specific areas that the artist has strong views about. For example, he may not wish to be featured in a group show with some artists, or have his work reproduced in magazines that go against certain philosophies. If you wish to establish any such conditions, make sure they are spelled out in the contract.

Damage. If work is damaged while in the gallery's possession, although the insurance will probably compensate, the artist may have strong views about how the restoring is done, and by whom. (See the Appendix on framing and conservation.)

Studio Visiting Rights. A gallery will generally want to come and look around an artist's studio periodically to see how work is progressing or to bring collectors. This is a common practice.

If after you have taken all the precautions outlined above, the relationship still breaks down, there are a number of positive steps you can take.

Arbitration. If the artist and the gallery wish to go to arbitration to settle their dispute, they can approach the American Arbitration Association, which has branches in most cities in the United States. For a small fee and in an informal atmosphere, a panel will hear the merits of a case and pass down a decision.

A simple form can be drawn up at the time a contract is signed between an artist and a gallery stating that, in the event of a dispute, both sides agree to go to arbitration and be bound by the court's decision.

There are other private arbitration committees that have been set up by artists' groups in various areas of the country.

Arbitration is often the simplest and least expensive method of settling a dispute.

Artists Equity. Artists Equity Association, Inc., is a national organization with members from all branches of the

visual arts. Most large cities have a branch of Equity, though it may be rather difficult to find. If you want to get in touch with one, it might be best to write to the headquarters at 3726 Albemarle Street, Washington, D.C. 20016. They will put you in touch with a branch near you.

Artists Equity has a lawyer in each geographical area who acts for them on a voluntary basis. If your case merits it, they will usually write to the gallery on your behalf. Often, a letter on legal stationery is sufficient. The service should cost you nothing other than the lawyer's expenses and the membership fee of Equity, which is currently seventeen dollars fifty cents plus a levy from the local branch.

See the Appendix for further information on art organizations.

Small Claims Court. The county courthouse usually has a small claims division which can tell you about the necessary procedures to follow and the costs involved which vary from state to state. Generally, the court will handle claims dealing with sums of seven hundred fifty dollars or less. It will cost about two dollars to register a claim, which is done by filling out a simple form. There is a further charge of eight fifty or so to cover the cost of the marshal serving the summons on the person you are suing. If you are suing someone from another city but in the same state, the eight fifty and a copy of the complaint must be forwarded to the marshal in that city. Interstate suing is not recommended, because only very rarely will you be able to collect your money.

The case will generally take three to four weeks to come to court and is heard before a judge, with no lawyers present.

Lawyers. If all else fails, consult a lawyer.

CHAPTER 9

copyright, authentication and insurance

When Robert Indiana produced his LOVE sculpture, he failed to copyright it in any way. It has since been adapted countless times without any consultation with Indiana and without any royalties coming to him, a situation he has described as "the biggest single disaster of my life." If he had copyrighted the work, he would never have had cause for complaint, and he would have been many thousands of dollars richer.

WHAT IS A COPYRIGHT?

A copyright gives the artist the sole right to make copies of his work and sell them, or to develop the work. If anyone does infringe upon the copyright, the artist is entitled to damages and can prevent a repetition of the incident.

Protection is available for artists in every medium including printmaking, photography, sculpting and painting.

Preliminaries

Once a work enters the public domain without copyright, all rights are automatically lost forever. Therefore, it is absolutely essential that a work be copyrighted before it is put on display or sold. The process of obtaining that protection is relatively simple. All that is needed is the artist's signature somewhere on the work, accompanied by the words "Copyright," "Copr." or "©." Although not essential, it is worth putting the date of execution on the work as well.

All the details must be in position to give reasonable access to them, meaning, for example, it is pointless to copyright a work if the notice is on the top of the head of an eight-foot sculpture. The new (1978) copyright regulations regarding the placement are as follows:

1. Notice may be placed on the front or back of a two-dimensional work, or it can be placed on the backing, mounting, matting, framing or other material to which the work is attached.
2. Notice may be permanently secured to any visible portion of a three-dimensional work or to a base, mounting, framing or other material to which the work is attached.
3. If the work is of a physical nature that does not lend itself to the notice being written directly on the work or written on a label, the notice may appear on a tag that is of durable material and is attached so that it will remain there permanently.

To copyright a work that is going abroad, all that is needed is the symbol ©, the artist's name and the date of creation. All countries that have signed the Universal Copyright Convention are then bound by the same restrictions that apply in the United States.

Copyright duration at this time is for the life of the artist, plus fifty years. If two artists work on one work the copyright endures for the life of the last survivor and fifty years.

Registration

It is not strictly necessary to then register the claim for copyright. This can be done at a later time, or when the artist feels that the copyright might have been infringed upon.

Applications for a "Registration of a Claim for Copyright" are available free from the Register of Copyrights, Library of Congress, Washington, D.C. 20559. The fee for registration is ten dollars.

There are different forms for the various disciplines. Form G is for works of art or designs for works of art, Form H for reproductions of works of art, Form J for photographs and Form K for prints and pictorial illustrations.

Each application must be accompanied by two photographs of the work (one of each side if it is three dimensional). In some cases the copyright office will offer a kind of group discount. For example, a photographer who wishes to copyright a series of twelve photographs could submit a composite sheet containing a number of prints, or a painter could submit a composite sheet with photographs of several works when copyrighting them for reproduction purposes.

Printmakers have to deposit two copies of the print. This is important to remember before destroying the negative image.

Assignment

Under the present law, an artist is assumed to have passed on the copyright when the work is sold. Unless specific provision is made to the contrary, the purchaser of a work may do with it exactly what he wishes. Thus, a great personal triumph can end up as a doormat. New legislation is under consideration however, which will reverse the law so that the artist retains the copyright unless it is specifically stated otherwise. Until that time, a written contract or agreement should be made to protect the artist. If the copyright is assigned, the copyright office should be informed.

Special Rights in Photography

A photographer has at least eleven different rights he can retain or sell at will.

1. *First Rights:* The photographer sells the right to a buyer to use a particular photo before anyone else. Until the buyer uses the photo (within one year) the photographer cannot sell it elsewhere.
2. *One-Time Rights:* The photographer sells the right to use a photo once in any copyrighted medium. Rights return to the photographer after the photo is used.
3. *Serial Rights:* The photographer sells the right to use a photo in a periodical.
4. *Second (Reprint) Rights:* The photographer sells the right to reprint an already published photo. Sometimes reprint rights are sold to the buyer of the first rights if the buyer wants to use the photo twice.
5. *All Rights:* The buyer owns all rights and may use the photo as many times as he pleases without further payment to the photographer.
6. *Exclusive Rights:* Synonymous with all rights with further description. The buyer may want all rights for only one year.
7. *Book Rights:* The photographer sells the right to use a photo in a book or on its cover.
8. *Country Rights:* The photographer sells the right to use a photo in a certain country.
9. *Language Rights:* The photographer sells the right to use a photograph in countries sharing a common language.
10. *Simultaneous Rights:* The photographer sells the right to use a photograph simultaneously to more than one party.
11. *Promotion Rights:* The photographer allows the purchaser to use a photo that has already appeared in a

medium such as a magazine or a filmstrip in promotion of that medium. For instance, a dust-jacket photo can be used in advertisements promoting the book if the promotion rights to that photo have been published.

ROYALTIES

In most of the countries of Europe there exists a law known as the Droit de Suite which gives the artist the right to benefit from the rise in popularity and value of his work over a number of years. Under the law, the artist receives a certain amount of royalties every time a work is sold for a profit.

In the United States, however, after a work has been sold, the artist is generally left with no residual rights at all. If a work increases in value tenfold, the artist will not receive any benefit when the work is resold. For example, Andy Warhol's major canvases sold for about twelve thousand dollars in the 1960s. Today they change hands for around sixty thousand dollars privately and at auction.

Many people have felt the need for a new law in the United States, and in some places pressure groups have brought about a change. California is the first state to have actually passed legislation to help artists retrieve royalties from their work.

California Resale Law

The California Resale Law came into effect on January 1, 1977, and contains the following important provisions:

1. The law applies to work by living artists.
2. The disciplines of sculpture, painting and drawing are covered.
3. Any work resold in California or by a California resident anywhere in the world is covered.
4. The artist receives 5 percent of the sale price of any

work resold for one thousand dollars or more and at a profit.

5. The law is retroactive to all work of living artists bought before 1977 and which are sold after the law came in.
6. If the seller cannot locate the artist, then the 5 percent goes to California Arts Council.
7. The CAC in turn has seven years to locate the artist and after that it may use the money for its own use.
8. The royalty right cannot be waived unless it is for a higher rate.

The advantages of the new law are that for the first time in the United States, there has been legal recognition of the artist's right to some benefit as a work increases in value. There is pressure for similar legislation in New York and Pennsylvania and over the next few years other states may well follow suit.

There are disadvantages to such a law. The dealers in California are very upset about it and have instituted a court action to try to have it changed. They feel that the law will harm both business and artists, as collectors won't come to buy in California if they have to pay an extra 5 percent. They cite the case of Sotheby Parke Bernet, who have ceased selling the work of contemporary living artists in California since the law was passed.

The dealers also look on the law as an unwarranted interference in what they view as a private business transaction. Also, there are no effective penalties to the law and no method of ensuring that it works. Any checking is left to the artist and if he finds an infringement, legal action has to be taken at the artist's expense.

Authors and composers have been protected by a similar law since 1909. They have set up their own non-profit organization, the American Society of Composers, Authors and Publishers (ASCAP), to police the procedure and distribute any royalties. This seems to work very well and could act as

a model for artists. At present the California Arts Council is trying to set up a registry and accounting system to deal with resale money received.

Whatever the outcome of the controversy, the lawmakers should be congratulated for giving legal protection to artists for the first time. Much more power will be necessary to actually enforce the law, but it is at least a beginning. In the meantime, artists will continue to hold on to their best works to take advantage of the increase in value over the years.

Those artists who firmly believe in the principle of royalties have already been coming to their own private arrangements with buyers. But it should be pointed out that only the few artists with sufficient muscle and charm have been able to obtain the necessary letter of agreement. Also, this sort of agreement is not often legally enforceable. It is morally binding, however, and several artists who have made agreements for royalties of 10 percent or more have indeed received the monies due.

Some dealers are refusing to accept the new law and are testing its constitutionality in the courts. The artists, in turn, have formed the Artists Royalties Legal Defense Fund to push the cause and fight any legal battles.

AUTHENTICATION

A certification of authenticity provides a comprehensive documentation of your work from the time it leaves your ownership.

A certificate can act as an extra guarantee of the work which may prevent forgery (although authenticity papers have certainly been known to be faked). The certification can also increase the resale value of your work and thus add to the amount of any possible royalties. It may at times be helpful in compiling a catalog resume of your work. And it may be used during import and export to prove the piece is, in fact, a work of art.

A collector should be delighted with a certificate of authenticity. In fact, it is a highly recommended document, which can only be of benefit to all parties.

A certificate of authenticity for a unique work of art should be made with sufficient copies for all parties concerned including artist, dealer and collector. A sample certificate is in the Appendix. If a certificate is not used, make sure to include the following items in the substitute document:

1. Title.
2. Date of execution and current date.
3. Dimensions, that is, height, width and depth.
4. Medium—in full, including all materials and finish.

PITFALL: In case of an accident the information on material and finish will be of particular importance to the restorer of the work. Tom Wesselmann as well as many other artists has started including a list of materials on the back of each work. This can be done for all two-dimensional work and a suitable place, perhaps under the base, should be found for sculptural works as well. For insurance purposes all six items on the authenticity certificate are invaluable.

5. The artist's signature and a statement, signed by the artist, that the work is unique and original.
6. Name, address and telephone number of the buyer and the seller.

Authentication of prints is a more complex affair and a longer document is necessary. California has a statute relating to the sale of fine prints, the provisions of which can provide the basis for any document. Included are—

1. The name of the artist and the year the work was printed.
2. Whether or not the edition being offered is limited, and if so—
 a. authorized maximum number of the edition.
 b. authorized maximum number of the unsigned or unnumbered impressions, or both, in the edition.
 c. authorized number of artists, publishers, printers or other proofs, if any, outside the regular edition.
 d. Total size of the edition.
3. What has happened to the plate after completion of the current edition.
4. If there were any prior states of the same impression, and if so, what form they took.
5. If there were any prior or later editions from the same plate.
6. Whether the edition is a posthumous edition or a restrike, and if so, whether the plate has been reworked.

The more accurately you have kept records of your work, the better you will be able to deal with your gallery, with private sales or, in an emergency, with the court system. Tax and insurance information can be pulled from these records as well. A copy of each certificate should be retained by you and used as the basis for building a history of each piece. Besides the information listed above, you should try to—

1. Obtain the names of the collector and any subsequent buyer of the work with the date of sale and price paid.
2. Include a photograph of the work.
3. List exhibitions where a work has been shown, including dates, whether there was a catalog and whether or not the work was illustrated in that catalog.
4. Record mention of the work in any reviews, articles or books, including author, title, date of publication

and volume and page number as well as illustration notation.

5. Note the present condition of the work, including any repairs that have been made, with date and materials used.
6. Note any sale of the work at auction with the name and address of the auction house, date and type of sale and the sale results, including price and purchaser, or name of vendor if the work was not sold.
7. State the names of the gallery, agent or private dealer where the work is on consignment, with dates and addresses.
8. Note whether the work is in your possession, or if not, where it is being stored (studio, home, warehouse or perhaps it is on loan to a friend or museum).
9. List costs to you of producing the work, including number of hours of labor and material costs as well as any specific promotion costs.
10. State the sales price with note of commissions or discounts allowed. Include revisions of sales price if work remains unsold.

INSURANCE

The general "All Risks" house insurance policy should cover an artist's less valuable works. As a general rule, up to three thousand dollars' worth of art can be included under your normal policy. Everything above that must be the subject of a floater clause on your policy. It is worth asking your local insurance company for a quote. The insurance company will generally charge 4 percent of a work's value to furnish additional insurance, which can work out to be very expensive. Special insurance for an artist's work can be purchased from some companies at only 1 percent of the value, that is, ten dollars for a thousand dollars' value.

On every policy, it is important to specify exactly what

is being insured and how much each work is worth. If the works are lost in a fire, the insurance company's assessor is likely to be very unsympathetic to your claim that a Campbell's soup can is worth twenty thousand dollars. Whenever possible, supply photographs and gallery documentations of sales prices.

Alden Moffit was a painter who was having a small exhibition in his local library. The library was willing to arrange insurance and asked for an estimate of the value of the work. Alden had never exhibited before and put extravagant prices of ten or fifteen thousand dollars on each work, which was far more than the market would bear. The library refused to pay at the rates demanded by the insurance company, and the exhibition was delayed until it was explained to Alden that in the event of a claim the insurance company would want some verification of previous sales or justification for the prices being charged. Alden was eventually convinced that a total value for the works at thirteen thousand five hundred dollars was sufficient at this stage of his career and the exhibition commenced.

To insure the art at all, an insurance company may wish to impose all sorts of additional fire and security precautions. If this is necessary, a safe storage room may have to be developed.

Several artists' groups, including Artists Equity Association, New York Artists Equity Association and Foundation for the Community of Artists, offer insurance at attractive discounts to their members.

MODEL RELEASE

Another legal aspect of the art business for photographers to be aware of is the model release, a written contract between photographer and person(s) in the photo. The contract protects the photographer against any possible suit filed by the photo subject. This is especially important when the photo

is used for commercial purposes. A model release is not necessary when shooting in public or when covering news events, but it is illegal to publish photographs of people who are protected under the law, minors involved in crime, for example. Under normal circumstances, in dealing with a minor, the parent must sign the model release. When it is time to send the photo to a publisher, the artist must send along a photocopy of the release—never the original.

CHAPTER 10

taxes

INCOME TAX

An artist's gross income includes the monies received from the sale of work or for workshops, lectures, independent teaching or any activity that can be classified as self-employment. In other forms of employment, taxes have been withheld for you. You must pay taxes on prizes and award income except for a few, such as the Pulitzer or Nobel prizes, which are given for recognition of past accomplishments and are awarded without an application received from you.

You need not pay tax on awards where you are not required to render a future service as a condition of the prize. You need not pay tax on a fellowship grant if you are working toward a degree, if the granter is a tax-exempt organization, a foreign government, an international organization or a federal, state or local government agency. Any other fellowship is taxable income.

Remember, income made from a hobby is taxable as well.

To get the maximum benefit from the tax system, it is

absolutely essential to keep accurate accounts, so that you can make the proper deductions. The accounts need not be very complicated. A simple record of what has come in and what has been spent should be sufficient.

Both for your own benefit and in case the Internal Revenue Service checks your statements, keep all receipts and canceled checks. And it makes it much easier to recall an event if you write on each receipt what was spent and why.

At the time, keeping accounts will seem like a terrible chore, but there are many tax deductions artists can make and you will not be able to claim many of them without accurate accounts.

Losses made while participating in a hobby are not deductible. Business losses are. So it is important to satisfy the IRS that the work you do as an artist is not just a hobby.

The yardstick the IRS uses to determine your status as a business is as follows: If the artist has made a profit in the last two years out of five, then he is in business. If not, all the art completed in the previous year was only a hobby.

This rule is not rigid and it is possible to persuade the IRS that you are a serious artist by perhaps getting your dealer to vouch for you or proving that you work full time as an artist. Belonging to an artists' organization or having a resale number can be additional evidence. (See the section in this chapter on the resale license.)

Remember that you cannot avoid paying United States income tax when working abroad, unless you remain out of the country at least eighteen months.

DEDUCTIONS

Among the business expenses that can be deducted are—
Studio. Under the 1976 Tax Reform Act, no deduction is allowed for business use of a portion of your home which is used for anything besides your work. It has to be proved that

the portion of your home that you are deducting is used exclusively for your work as an artist.

If a portion of your home is exclusively used as a studio, then you may deduct only a portion of your maintenance, repairs and utilities. You may not deduct mortgage or estimated rental value. If you rent an apartment you may deduct the percentage of rent used for the studio as figured by square footage or number of rooms.

There is, however, no problem at all if the artist's studio is removed from the house and relocated within commuting distance. A complete deduction is then allowed.

Supplies. Art supplies that form a major expense of the work cannot be deducted until the work is sold. If, for example, a work was cast in bronze in 1975 and not sold until 1977, the cost of the bronze would be deducted in 1977 and not the year of the purchase. In the meantime, the material is said to be inventory.

Such items as paint and canvases can be deducted in the year of purchase.

Commissions, Salaries, Fees. All commissions paid to a gallery, private dealer, agent or co-op, any salaries to employees and fees for such things as juried shows can be deducted.

Entertainment. Any cost incurred while entertaining someone for business purposes can be deducted. The artist must keep a detailed record of the occasion including who was there, what was discussed and what, if any, sale resulted. Opening-party expenses can be deducted as well as expenses for business meetings (usually held over lunch or dinner) with dealers, other artists, museum curators, or potential collectors. What may appear to some to be entertainment, such as museum admissions, can be deducted by the artist.

Travel Expenses. Any journeys carried out in the course of business can be deducted. This includes the cost of running a car and any overnight stop that may have to be made. Again, all costs have to be verified by detailed receipts. The

IRS is not going to allow 100 percent deductions on any cost of running your car. Only those costs directly related to business will be allowed.

Travel expenses are those incurred on overnight trips and can include meals, lodging, fares, auto expenses, laundry, telephone and reasonable tips.

You cannot deduct auto or transportation expenses to and from work, but if you teach and create in one day you can deduct the travel between school and studio. You can use a standard mileage rate of 17 cents for the first 15,000 business miles and 10 cents for each additional mile. Or you can take a deduction based on actual cost of gas, oil, repairs, insurance and depreciation based on a business/non-business ratio.

Telephone. Only long-distance telephone calls made on the artist's own telephone and in connection with business can be deducted.

Insurance. The cost of insuring both the studio and any works of art is deductible. If you are unfortunate enough to lose an uninsured work during the course of a year, its value is also deductible.

Depreciation. All large items used in the studio by an artist for business purposes suffer from wear and tear. This wear and tear reduces the resale value of the article year by year. The reduction in value is known as depreciation, and once a figure is calculated it can be allowed for each year during the life of an item. For example, a glass blower might value his kiln at $10,000 and its life at 10 years. He would, therefore, allow $1,000 per annum as depreciation. This is not a figure that can arbitrarily be picked out of the air. You will know the price of the item and we suggest you get in touch with the local salesperson to ask what its life expectancy is.

Education. Fees and expenses incurred in the course of improving and maintaining the artist's ability are allowed.

However, money spent on getting qualified initially, such as a college degree, is not allowable.

Eligible education expenses include tuition, books, supplies, fees, related travel and local transportation. The IRS seems to challenge those applicants who seek education for employment advancement, pay increases, increased prestige or to satisfy personal educational goals. Education, for deduction, must be limited to maintaining or improving skills required by employment or trade.

If you remembered to keep the receipt, the expense of buying this book is deductible.

Charity. All expenses related to a donation to a charity or a museum and all the costs of materials in the work of art donated are deductible. The actual value of the work is not deductible.

Christine Speirs was an experienced teacher at California College of Arts and Crafts in San Francisco. She had been represented for some time by a new gallery. After failing for a certain period to receive any payment for work sold, she asked it for a full inventory of her work. She subsequently discovered that some of her paintings had been given by the gallery to charity. The gallery argued that by doing this it was getting some valuable exposure for her which may have been true. It also pointed out that it was deductible to her. But Christine felt that she should have been consulted. Her deduction was only $80 and the pictures would have netted her $500.

PITFALL: A collector is allowed a charity deduction of the current appraised value of his property up to a total of 20 percent of income. That means a collector with property valued at $200,000 can get a tax deduction on a charity donation of up to $40,000. The costs of material of an artist's own work could never come near this figure.

Dues. If you are an artist and a teacher you may be declaring business expenses such as professional association membership fees, professional subscriptions to art magazines or newspapers or trips to professional conventions or exhibitions. You cannot deduct these items twice and so you must decide which is applicable to a professional artist and which to a teacher.

ACCOUNTANTS

You may find it necessary or desirable to employ an accountant to fill out the actual tax forms. But you must be able to supply him with all the necessary information and receipts. A tax firm may help you to set up a good business diary. Remember, any fee charged by the accountant is deductible.

If you are not connected with a gallery but are receiving and spending fairly substantial sums of money, you should ask your accountant about incorporation, which can save you tax money.

APPEALS

If you wish to appeal an IRS decision, they provide a publication, No. 556, entitled "Audit of Returns, Appeal Rights and Claims for Refund," which shows exactly how to appeal a decision all the way to the tax court without incurring legal fees.

ESTATE TAXES

Income tax and estate tax are very different things. Income tax happens to us every year, like a bad cold. Estate taxes are a one-time affair which needs careful preplanning.

At the death of an artist, his estate will be taxed on the value of property he owns, less certain deductions. The

value of the estate is estimated to be the fair price the goods
would fetch on the open market at the time of death. Works
of art in particular are given their true market value and
not valued simply at the cost of materials that went into the
making of the work.

Fair market value is estimated by the IRS as "the price
at which the property would change hands between a willing
buyer and a willing seller, neither being under any compulsion
to buy or sell and both having a reasonable knowledge of
relevant facts."

Although this seems a fairly straightforward approach,
valuing an estate can become a very complex matter.

The case of the Estate of David Smith illustrates the diffi-
cult situation an artist faces, who wishes to leave his estate
sufficiently organized so that his family is not saddled with
a difficult burden after his death.

David Smith died in 1965, leaving 425 sculptures in his
estate.

The IRS valued the estate at $5,256,918. The executors,
on the other hand, placed a value of $4,284,000 on the
estate. This figure was discounted by 75 percent on the
theory that the works could only be sold to a bulk purchaser
for resale. They reduced the figure by a further third in order
to compensate for the commission payable to Marlborough
Galleries.

The IRS sued for the duty on the executors' figure of
$4,284,000.

After a lengthy court case, the estate was valued at $2.7
million and the family had to pay the tax on that amount.
Approximately eight and a half years after Smith's death,
the estate had realized $4.5 million in sales with half the
works still unsold.

A bill is currently before Congress which will allow
works in an artist's estate, which were made by that artist, to
be valued for tax purposes at the cost of materials. Tax would

have to be paid only if and when any of the work in the estate were sold on the open market. There would then be an adjustment between the price at the time of sale and the cost of the materials.

Deductions on Estates

The estate is exempt from all taxes if it is valued at sixty thousand dollars or less. If, however, an estate is going to be worth more than that, there will be taxes to be paid, but the following deductions will be allowed:

1. Funeral expenses.
2. Administration expense. This includes the cost of the lawyers and any other professional advice that may have to be sought to ensure a proper distribution of the assets.
3. Claims against the estate. Any debts that remain unpaid after an artist's death have first claim on the assets.
4. Charitable bequests. Any works left to charity are free of all taxes.
5. Marital allowance. Fifty percent of the artist's gross estate, less the above deductions, can be left to a spouse tax free.

Conflict of Interest

Mark Rothko was one of the leaders of the abstract expressionist movement in the twentieth century. When he committed suicide in 1970, he left 798 paintings to be disposed of by his estate.

These works were valued at around $14.5 million at the time of his death and are worth some $65 million now.

Rothko's will appointed three men as executors: Bernard J. Reis, an 81-year-old accountant and art collector who had drawn the will and was also a director of the Marlborough

Galleries, New York; Theodoros Stamos, a painter; and Morton Levine, Professor of Anthropology at Fordham University. All the men had been close friends of Rothko's.

Within three months of the artist's death, the executors decided to sell 100 of Rothko's best paintings to Marlborough for $1.8 million, the money to be paid over twelve years without interest. They further agreed to consign the remaining 698 paintings to Marlborough for sale at 50 percent commission.

Soon after the agreement was made, Stamos made a contract with Marlborough to handle his own paintings at terms more favorable than those negotiated for the Rothko works.

The Rothko family sued the executors and after a lengthy court battle the judge canceled the contract between the executors and Marlborough and imposed a fine of $3.3 million on Marlborough Galleries and its head, Frank Lloyd, and damages of $5.95 million on the executors, which was the estimated value of the paintings already sold.

Two things of interest emerged from this case:

(1) The judge cited the conflict of interest of the two executors Reis and Stamos. Any possible conflict of interest should be borne in mind when making a will and appointing executors.

(2) Marlborough is perhaps the biggest international art gallery group in the world. It is the brainchild of Frank Lloyd, who has steamrollered his way to lead the art market by being fiercely competitive.

Before the contracts with the estate were executed Marlborough had organized a worldwide promotion campaign for Rothko's works. This greatly increased the value of the paintings in Marlborough's possession and aroused widespread interest in his work.

Marlborough's involvement in the case is perhaps illustrative of the way a major, highly successful art gallery can, in

today's market, attempt to mold both the law and the art-buying public to suit its highly developed business needs.

SALES TAX AND THE RESALE LICENSE

It is possible to get away without paying the sales tax on art supplies by means of a resale license, which helps establish the artist as a manufacturer. An application to the State Board of Equalization should get the artist both a license and a resale number. If the number is quoted when purchasing art supplies, the tax should not be applied.

When the artist applies to the Board for a license, it may ask for a deposit of taxes in advance, though it will waive this if it imposes a financial hardship on the artist. If a deposit is made, the Board keeps the money for five years. If the artist does not sell as much as expected, it will refund the difference.

If the artist sells through a gallery, it may be possible to borrow the gallery's resale number for purchases.

Every artist must charge sales tax to the buyer of his works and pass the tax on to the state. If he does not charge sales tax and has a resale license, the artist breaks the law. There is always the danger that the IRS will find out years later, and a large bill for back taxes may suddenly appear.

IMPORT AND EXPORT

There is no statute limiting the types of art that can be imported or exported, nor are there any restrictions on the value of works of art to be taken in or out of the country.

However, if a foreign country can prove that a work of art is a national treasure or has been stolen, it may have to be returned to the country of origin.

In recent judgments, the courts have taken a very liberal view on what can be described as a work of art. Originally,

the law was very limited, but it has now been broadened to include most modern art.

If an artist is temporarily abroad and a work is sent back to the United States for exhibition, the artist must send a note with it verifying its authenticity. The authenticity form in the Appendix would be useful in this instance.

CHAPTER 11

the government

State and federal involvement in the arts has increased enormously in recent years. The proliferation of such organizations as the National Endowment for the Arts, the Economic Development Administration, the Comprehensive Training and Advisory Council and the State Art Councils confronts the artist with a bewildering bureaucracy that has spawned even more agencies whose sole purpose it is to explain what, and how, to the layperson.

There are now many opportunities for artists to get exposure for their work and perhaps obtain state or federal subsidies, if they only know which organization to approach.

It is the intention of this chapter to explain the complex relationships among the different agencies and to provide some information on how you can benefit from the millions of government dollars being poured into the arts annually .

THE NATIONAL ENDOWMENT FOR THE ARTS

The NEA was founded in 1965 to help strengthen the arts professionally and to ensure that "American life is enriched by their aesthetic, intellectual, social, spiritual and practical contributions."

The Endowment's current provisional Five Year Plan projects appropriations of $154, $170, $200, $250 and $300 million for the period 1980 to 1984. The $7.4 million allocated for the visual arts program in fiscal 1980 is not the largest among NEA's program areas (dance, expansion arts, media arts, music, theater and museums all receive more), but it does show the largest increase (from $4.5 million in 1979).

Moreover, the increase reflects a major priority, which is for more money for individual artists. NEA plans to triple the number of fellowship awards to about 750 by 1984, and increase the top amount to $12,750 from the present $10,000.

The NEA is committed to supporting not only the visual arts, but also music, literature and architecture, as well as 114 other categories. In fact, in 1978, the visual arts received only 4 percent of the total NEA budget. Museums, which are categorized separately, got three times that. Such patronage of the establishment has been criticized as a misguided use of valuable resources. Nonetheless, at a recent seminar sponsored by the NEA, it was announced that existing institutions and recognized artists would receive funding in preference to more experimental areas of art.

Included in the NEA's budget is sponsorship of short-term residencies, workshops and alternative spaces, photography and crafts exhibitions, performing arts groups engaging visual artists and the training of new craftspeople.

The growth of the NEA's budget has been matched and perhaps surpassed by the increased size of its administration. If you wish to apply for a grant, the NEA will supply you with an 84-page booklet which explains the machinery involved. Their address is given in the Appendix.

If you wish to make an application, it is essential that it be sufficiently detailed to pass through an administration that has to process 18,000 such forms. The NEA is interested in the nature of the project, the cost, the background of the

people involved and who is likely to benefit from the project's completion.

Any organization applying must be tax exempt and non-profit. The support of your local Arts Council will be of help in this case, as it is probable that you will have to match the NEA's grant with an equal amount of money from another source.

It may take as long as three months to process the application, extending from one of the quarterly deadline dates. During that time, the proposal will go before a panel of judges appointed by the chairperson of the NEA. The panel will probably include four people from the art world: perhaps a curator, an artist, a collector and a museum trustee.

The panel's recommendations for grants go to the National Council on the Arts, who generally will approve the grants. (See the following section on the National Council.)

Typically, a printmaker or a painter will get $7,500 outright just by asking for it, or a community might get a $50,000 matching grant to commission a major outdoor work.

In 1976, of approximately 6,600 applications for individual fellowships in the visual arts program, 285 received grants totaling $1.3 million, or an average of $4,562 each.

There are organizations, especially at universities, that will help you complete a grant application, but there is no harm in applying by yourself. As with all grants, one should know what areas are getting special interest, and knowing someone on the selection committee is highly advantageous. After that, it only takes a form filled out in triplicate. If your project is thought to be worthwhile, you may get an opportunity to complete it in financial peace.

The NEA is the organization that guides and directs other state and federal agencies. As will be seen later in the chapter, before making a decision about approving an artist or commissioning a work, the agency will probably consult the NEA. It cannot hurt, therefore, to make your name known in the organization by filing an application. A newsletter is

issued by the NEA called *The Cultural Post*. It can be obtained by writing to the NEA, Washington, D.C. 20506, and asking for a subscription.

NATIONAL COUNCIL ON THE ARTS

The NCA is composed of the Chairperson of the NEA, who also serves as Chairperson of the Council, and of twenty-six other people, appointed by the President, who are considered to be involved in the arts.

The Council's primary function is to advise the Chairperson regarding policies, programs and procedures for the NEA. Its other function, which is perhaps of most concern to artists, is to review all grant recommendations that come before it.

The Council meets only four or five times a year and obviously has to process a huge quantity of applications. Seldom, therefore, do individual applications get very close scrutiny, although it has been known for the Council to attempt to reject an application it considered too partisan (the attempt failed).

CETA

The Comprehensive Employment and Training Advisory Council was set up to ensure that funds are "equitably distributed to those segments of the labor force which are significantly burdened with high unemployment and those who have structural barriers to employment."

CETA was created by Congress in 1971 and is financed by funds allocated by Congress and administered locally under federal guidelines. The money is channeled to cities and towns and is always distributed by an elected body, generally the Board of Supervisors. In 1977, total funding for CETA nationwide was $5.6 billion.

CETA tries to solve a threefold problem in the area

of the arts. First, in a time of high unemployment, artists often take unskilled positions away from laborers who are genuinely without developed skills. Second, there is an opportunity to stimulate employment by raising the level of cultural activities. In other words, support of the arts will create jobs in such arts organizations as galleries and community cultural centers, which in turn creates jobs for the semi- and unskilled labor force—maintenance people, packers and shop workers. Lastly, there is the problem of artist unemployment itself and lack of enhancement of life because of that unemployment.

All the jobs provided by CETA are temporary. Their duration may vary from state to state, but eighteen months seems to be the average maximum length of a job.

There are three different categories of applications to CETA: those of an individual person, of an organization and of a group of three people.

As an individual, it is necessary to approach the local CETA office in person to fill out an application form. Every county has an office and the local Department of Labor will refer you.

The individual's application is assessed primarily by a means test, which takes into account the time the applicant has spent unemployed and his or her total income in the last three or twelve months, whichever is more advantageous. All members of the family unit are considered in the means tests.

To qualify for some of the benefits under CETA requires the income of a family of two to not exceed $3,930, or $5,850 for a family of four. These figures vary depending on what sort of position you are applying for.

To take into account different needs in different areas, applicants are also processed on a points system, which may vary from state to state. Aside from financial considerations, the reviewer will take into account such things as disabilities, minority status and veteran status.

If you qualify for CETA help, the organization will act

as a sort of employment agency to find you work and then
subsidize your salary.

If your application for work fails or there is no work
available but you wish to remain an applicant, it is necessary
to be recertified every ninety days.

If you are offered a job, you can expect it to last a
maximum of eighteen months. You will then be expected to
transfer to some form of permanent employment, or return to
the unemployment line.

An organization, provided it is a non-profit organization,
may also fill in a grant proposal for funding. Monies will not
be supplied for overall running expenses but only for a specific
job position. For example, if a jewelry workshop was unable
to pay the cost of a teacher one year, application could be
made to CETA, who might agree to underwrite the salary.

Under Title VI of CETA, which is of particular interest
to artists, a group of three people can apply for funding for
some kind of public-service project. The project must last a
maximum of one year and employ three people. For example,
three artists might suggest painting a mural on a wall near the
city swimming pool. CETA might agree to fund such a
project.

A non-profit organization, such as the local Arts Council,
can also sponsor a CETA position, say, a marketing developer
for an area. This person could take up to eighteen months to
research markets and develop guides for artists in selling their
work.

THE ECONOMIC DEVELOPMENT ADMINISTRATION

Under the auspices of the Department of Commerce, the
EDA is charged with encouraging the creation of jobs in
economically depressed communities.

The EDA takes a far broader view than most agencies
and will give money to such projects as a city center rede-
velopment, which will generate jobs for a lengthy period.

Grants are also sometimes given in the arts, as were the $1.7 million grant to the city of Sacramento to renovate the E. B. Crocker Gallery, and the $1.27 million grant to the city of Garden Grove, California, for the construction of an outdoor amphitheater.

Often these projects need artists and others with art-related skills. Therefore, it is worth keeping an eye out for any announcements of EDA-funded projects, and then applying to the project manager.

STATE ARTS COUNCILS

Every state has an Arts Council, whose basic function is to offer grants to artists in all disciplines in order to promote art in the community.

Funding comes from the state and the NEA, and varies greatly across the country.

There has been some criticism of state councils, because the inner council, which ultimately sanctions grants to artists, is generally made up of political appointees of the governor. It has been noted in the past that these appointments have been made not because of knowledge of the arts but because of some past political service that may have been rendered the governor.

Be that as it may, state councils are a valuable source of support for artists and generally act in an independent fashion that supports originality and experimentation.

Grant applications are made according to guidelines set out by each different state. These are then reviewed by the staff of the council in conjunction with an advisory panel, which is composed of artists. Their recommendations then go before the inner council for approval.

Although grant policy varies from state to state, the general rule is that an organization, workshop, co-op or teaching project will stand a better chance of being awarded a

grant than an individual. Some states, one of which is California, no longer award grants to individuals at all.

Grants offered to organizations usually range from $5,000 to $20,000, although again this may vary from state to state.

State Arts Councils are also an excellent source of information on what is happening in the area. Most publish some sort of newsletter, which gives information on new legislation, available grants with application details, and useful addresses.

ART IN FEDERAL BUILDINGS

It is now law that three-eighths of one percent of the construction costs on new federal buildings must be spent on art.

The General Services Administration is responsible for ensuring the letter of the law is carried out and commissioning artists to do the work.

If you know of a new federal building that is planned for your area, try to get in touch with the director of the GSA's fine arts program himself. You can find him in the telephone book under U.S. Government, under the subheading General Services Administration, and the listing for Public Building Service or Building Management. If you are lucky, there will be a listing for Building Manager and the address.

Visit the space, looking for places that would be appropriate for art. Make a plan for use of the space. Include costs of material and labor, insurance, transportation and hanging. The more professional and well thought out the project is, the easier it will be for your idea to be processed. Take into consideration the users of the building and the general public who will see the work—a great deal of aesthetic judgment will be made on their behalf.

Then approach the building manager and present your plan.

Before commissioning any work, the GSA consults with the NEA's visual arts program. The NEA's director of visual arts draws up a list of artists and art-related people to serve on the selection panel.

Joined by members of the GSA and the architects designing the building, the NEA advisory panel nominates artists for the project. They then submit between three and five names to the Art-in-Architecture Design Review panel of the GSA. They, in turn, select one name, which then must be approved by the administrator of the GSA.

The whole process can, obviously, be very lengthy.

Several horror stories have been told of artists who have handed commissioned work over to a government agency only to see it installed incorrectly or maintained poorly. Unfortunately, once the work is sold, the artist has no control over what is done with it.

One artist in France had been commissioned by the Renault company to produce a mosaic. After he worked on the project for several years and having almost completed his life's masterpiece, the company had a change of policy, cemented the work over and turned the area into a car park.

Things may not be quite as bad as that in the United States, but the danger of abuse is always there, and any artist working for the GSA must be aware of that fact. Try to be as specific as possible when contracting for such a job, and do your best to negotiate control over the installation and the future of your artwork.

ART IN PUBLIC BUILDINGS

There has been considerable pressure from artists' action groups to persuade states to allocate one percent of the cost of all new buildings for the purchase of art.

To date, this has had limited success. Some states have set aside a fund to be administered by the State Architect's

office to promote art on both old and new buildings. Others have done nothing.

The outlook for a nationwide response to the call for more art on state buildings is not good. Most states are looking for ways to curb their budgets, not expand them. Should the economic climate improve, however, the situation could change.

California is an example of a state which has appropriated money to commission art on public buildings all over the state. Three hundred thousand dollars was allocated in 1979 to benefit twenty-five artists. One million dollars is provisionally budgeted for 1980.

To be eligible under the program, which offers grants from five thousand to one hundred thousand dollars for one project, it is necessary to register with the local Artists Registry (see the next section).

The actual program is administered by the office of the State Architect, with some advice from the Arts Council. It is the state architect who draws up a short list of buildings that he feels would benefit from the program.

The ultimate choice of which buildings will get the work of art is made by the State Architect, a representative from the Arts Council and another individual chosen by those two.

In each community to receive works of art under the program, town meetings are held to get the views of local people about the art they would like to see on the building concerned.

The town meeting elects a task force, whose job is to review the applications submitted by the various artists interested in completing the project.

In order to save a great deal of time and energy, it is worth sounding out grass roots opinion in the community on the kind of art desired. Of course, it is also essential that you examine the building concerned.

The selection board will generally be expecting a proposal that includes a resume, a description of the work proposal, a budget for the work and an illustration of the work. The whole package should be labeled with the site name, address and region.

The task force selects from one to five names from among the applicants to recommend to a regional panel, made up of elected members from each of the task forces. The regional panel makes recommendations to a statewide panel, who actually makes the decision.

All town meetings are held in January and February, and regional panels have to make recommendations to the statewide panel by April. The statewide panel has to make its decision in May and all approved art projects should be contracted by the end of May.

Although California is only one example of the system in operation, all states that have an appropriation for art in public buildings have a similar structure.

ARTISTS REGISTRY

To take advantage of many of the state and government plans offered to help the artist, it is often good advice to make sure your name is on the Artists Registry held by each state.

In some states, commissions and grants will not be offered to artists who have not registered. CETA also looks for confirmation of your status through the registry.

In California, where there is an artist's royalty law, registration helps locate you for royalty payments. This will probably apply to other states as the law is enacted in each.

If you have to apply for a resale license (see Chapter 10), your professionalism is readily established if you are on the Registry.

Applications to join the Registry can be obtained di-

rectly from your local Arts Council, or from your local art association. Usually, the only information required is what would normally be found on your resume.

There are several registries that charge a fee to have your name listed. Such a registry also asks for the submission of slides and photographs. It will offer to place your work in exhibitions and help you with sales. Be very careful to check the reputation of a registry before you consider paying a fee.

appendix

NOTE: This is intended only as an example of what a resume might look like. You will have to make adjustments to the different headings according to your own experience.

RESUME

Name: Stephen Holt

Address: 1325 Myrtle Avenue, Hartsdale, Vermont 10029

Telephone: (802) 020-9964

Place and Date of Birth: Cincinnati, Ohio, October 17, 1947

Medium: Oil on unstretched canvas

Schools and Qualifications:

Missouri 1965–68, BFA

San Francisco Art Institute (SFAI) 1969–71, MFA; major: painting.

Selected Solo Exhibitions:
 Balman Gallery, San Francisco, 1972.
 Barrios Gallery, Sacramento, 1972.
 Galeria del Sol, Santa Barbara, 1973.
 Green Gallery, New York, 1974, 1975.
Selected Group Exhibitions:
 10 New Western Views, Green Gallery 1972.
 Contemporary Painters, USA, England, Canada, Serpentine Gallery, London, 1975.
 Annual Exhibition, Whitney Museum of American Art, New York, 1976.
Awards and Prizes:
 Young Painter Abilities Award, Washington University, 1967.
 Full Tuition Scholarship, SFAI, 1970.
 Teaching Assistantship, SFAI, 1970, 1971.
 SFAI Annual Prize, 1974.
 Purchase Award in Painting, Oakland Museum, 1975.
Work in the Collections of:
 Albright-Knox Art Gallery, Buffalo.
Reviews:
 ARTnews, Feb. 1974, "Holt—1970 Views of 1950," Bob Felderman, p. 28.
Personal Bibliography:
 "Art Bop," *The Village Voice,* Feb. 10, 1975.
Professional Organizations:
 Artists Equity, Artists for Economic Action.
Art-Related Professional Experience:
 Instructor, California College of Arts and Crafts, 1973, 1974.

SAMPLE CONTRACT I

NOTE: This sample contract is a realistic example of what you can expect from a gallery. We have included another sample contract drawn up by Artists Equity, which contains more detail.

Name of Gallery
Address
Telephone

ARTIST–DEALER AGREEMENT

Artist's Name _____ Date _____
Address _____
Period of Contract: From _____ To _____

Terms of Exhibition:
 1. List of Work: _____
Itemize on attached paper giving title, medium, dimension and price.
 2. Gallery assumes all responsibility for insurance and claims made on work lost, stolen or damaged while in the gallery's possession.
 3. Printing announcements, mailing, refreshments for opening party to be paid by the gallery.
 4. Publicity and advertising will be at the expense of the gallery.
 5. The artist is responsible for the delivery and collection of work to and from the gallery.
 6. Commission to gallery 50%, to artist 50%, on the retail price of all gallery sales of the above artist's work.
 7. Conditions of payment: Outright sale, due 30 days with receipt of full payment.

8. Gallery assumes all risk of customer's credit. All losses due to bad credit risks are to be borne by the gallery.

9. All reproduction rights are reserved by the artist.

10. An inventory balance is to be sent to the artist every six months from the date of this agreement. Complete records of the works are to be kept by the gallery while it retains possession.

11. The gallery has exclusive rights in this state for the sale of work.

12. Artist's work must be shown by the gallery on a regular basis for the duration of this contract.

13. The artist agrees not to sell any work shown in the gallery for less than the gallery price during the period of this contract.

Signed _____
 Artist

Signed _____
 Director

SAMPLE CONTRACT II

ARTISTS EQUITY ASSOCIATION, INC.
MINIMUM ARTIST–DEALER AGREEMENT

Prepare this agreement in duplicate. N.B. This agreement should not be considered the last word in artist–dealer contracts. Artists Equity's National Board holds that the best agreements are carefully tailored to meet the specific needs and interests of the artist and dealer involved. Therefore please feel free to adapt and modify the terms set down here to meet your own needs, interests and opportunities. You may also find it wise to enlist the assistance of an attorney skilled in drafting contracts.

Artists Equity's National Office receives many requests for advice regarding appropriate trade discounts to dealers. Such discounts vary widely, depending entirely upon the services performed by the dealer for the artist, and no general rules can be established. For example, a dealer who absorbs the entire cost of an exhibition may well be entitled to a better discount than one who shares such costs with the artist. Obviously, a dealer who purchases works outright is entitled to a better discount than one who sells consigned works.

It is hereby agreed between ————————————, the artist, address: ————————————————————— and ——————————, the dealer, address: ——————————— —————————— that the dealer shall exhibit the artist's work at the dealer's premises under the following conditions:

1. The works hereby consigned for exhibition and sale by the dealer as agent for the artist are enumerated, described, and priced at retail on the attached list. Such works are warranted by the artist: to be free of inherent vice, to be his/her own original creations, and to be the unencumbered property of the artist. They shall remain the property of the artist unless and until they are purchased by collectors or by the dealer.

2. The works here listed shall be exhibited by the dealer from —————————— (date) to and including —————————— (date). These works shall constitute a solo/part of a group (*choose either term*) exhibition. Such exhibitions shall be held approximately every —————————— months.

3. Approximately ——————— works on the attached list shall be hung during the exhibition period. The remainder shall be available for inspection by prospective purchasers. After the exhibition period, the artist's consigned works may be retained by the dealer for sale for a term of ——————— months. At the end of that period, they may be individually removed by the artist providing five days prior written notice has been given. Other works may be supplied as additions or replacements for works sold or removed from time to time by mutual written agreement of artist and dealer. The terms for retention of works may be thereafter extended annually by mutual written agreement.

4. The artist will assist the dealer by: (*select appropriate responsibilities/eliminate inappropriate items*)
 a) crating and shipping works to the dealer,
 b) framing the works for exhibition,
 c) furnishing advice, cooperation, and assistance in advertising and publicizing the artist's work,
 d) furnishing data regarding prospective and existing collectors.

5. The dealer will pay the artist ———————% of the retail sales price on any works sold. Notice of all sales, including the name and address of purchaser will be given to the artist at the conclusion of each month and payment of all monies due shall be made not more than thirty days after the receipt of payment by the dealer. The dealer assumes full risk of non-payment by the purchaser. However, if a work is returned in good condition by a client for credit, the dealer will make appropriate pro rata adjustments in future payments to the artist.

6. During the term of this agreement or any extension thereof and during the shipment to the artist of works from the dealer, the dealer shall cause all of the artist's works consigned to the dealer to be insured to the benefit of the artist against any and all loss in an amount equal to the artist's portion of the retail sales price.

7. No unsold works shall be removed from the dealer's premises and no discounts shall be permitted except by specific permission of the artist.

8. The artist shall have the right to inventory all consigned works at reasonable times and to obtain a full accounting for any works not present at the dealer's premises at such time.

9. The artist reserves all rights to the reproduction of works in any manner. This restriction shall be indicated by the dealer in writing on all sales invoices and memoranda. However the artist will not withhold permission for the reproduction of such works for promotional purposes.

10. During the term of this agreement, the dealer will exclusively represent the artist in the following geographical areas:

However, the artist takes the following exceptions to such exclusive representation * (e.g., *The artist reserves the right to sell works from his/her own studio. In this case, the artist will remit* _____% *of the proceeds of such sales to the dealer.* _____

11. Costs of crating and shipping shall be absorbed as follows: (*Indicate responsibility of artist and/or dealer*)

12. Promotion and advertising costs shall be absorbed as follows: (*Indicate responsibility of artist and/or dealer*)

13. Costs of an exhibition opening in conjunction with the exhibition provided above shall be absorbed as follows: (*Indicate responsibility of artist and/or dealer*) _____

14. In the event that a dispute arises under this agreement involving the interpretation of any of the provisions herein which cannot be resolved by discussion between the artist and the dealer, both parties will submit such dispute to an arbitrator appointed by the American Arbitration Association, who shall

decide the issue in accordance with the terms of the agreement and the laws of the State of _____. Costs in such cases shall be borne equally by both parties.

_____ _____

Artist Dealer

_____ _____

Date Date

* *Eliminate if not appropriate.*

SAMPLE RECEIPT

Name of Gallery
Address
Telephone

RECEIPT FOR ARTIST'S WORK TAKEN ON CONSIGNMENT

Name of Artist ⎯⎯⎯⎯⎯⎯⎯⎯⎯⎯⎯⎯⎯⎯⎯⎯
Address ⎯⎯⎯⎯⎯⎯⎯⎯⎯⎯⎯⎯⎯⎯⎯⎯⎯⎯⎯⎯
Telephone ⎯⎯⎯⎯⎯⎯⎯⎯⎯⎯⎯⎯⎯⎯⎯⎯⎯⎯⎯
Date Work Received ⎯⎯⎯⎯⎯⎯⎯

Title of work, medium, size price

Work to be collected on ⎯⎯⎯⎯⎯⎯
Work is insured Yes/No

Signed ⎯⎯⎯⎯⎯⎯
 Artist
Signed ⎯⎯⎯⎯⎯⎯
 Director

Work Returned to Artist on ⎯⎯⎯⎯⎯⎯
 (date)

Signed ⎯⎯⎯⎯⎯⎯
 Artist

Signed ⎯⎯⎯⎯⎯⎯
 Director

MULTIPLE ORIGINAL WORK OF ART

Name of Gallery
Address
Telephone

Date ——————, 19——

Title ————————————————

Dimensions ——————————————

Medium ————————————————

Edition Size ————————————

Description of Work ——————————————————

———————————————————————————————

———————————————————————————————

———————————————————————————————

———————————————————————————————

I hereby warrant that the multiple original works of art described herein were created by me and executed with the assistance of:

———————————————————————————————

———————————————————————————————

These original, hand signed and numbered works were conceived on or about ——————, 19—— and were executed in ——————, 19——. They consist of: (Describe images briefly in terms of forms, colors, and methods employed.)

———————————————————————————————

———————————————————————————————

———————————————————————————————

———————————————————————————————

Materials employed: ——————————————————

———————————————————————————————

Record of the edition: (For original prints, identify all existing or planned works in the edition, including printer's proofs, trial proofs, artist's proofs, standard proofs, cancellation proofs, etc. For sculpture and hangings identify castings already finished or planned, weavings finished or planned, etc. Indicate whether special states exist. Indicate identification system employed.)

———————————————————————————————

———————————————————————————————

———————————————————————————————

All other (proofs/castings/hangings) have been destroyed. The (plates/stones/cartons/molds) employed to make these works have been (effaced/destroyed/stored until the edition is completed, at which time they will be effaced/destroyed).

These multiple original works of art are in no sense copies, duplicates, or reproductions of other art works but represent originals of my own creative expression. They are strictly limited in number, as detailed above, to a total of _____ works.

Artist

CERTIFICATE OF AUTHENTICITY

UNIQUE WORK OF ART

Name of Gallery
Address
Telephone

Date ————————

Title ————————
Dimensions ——————————
Medium ————————

 I state that the above unique work of art was created by me. I created the work on or about ————————. It consists of: (Describe materials employed) ————————————————
————————————————————————————
————————————————————————————
————————————————————————————
Finishes employed: (Describe in detail) ————————————
————————————————————————————
————————————————————————————

This original work of art is in no sense a copy, duplicate or re-production of any other art work but represents my own original creative expression. It exists only in this unique state. It has been signed by hand.

I was assisted by ————————————————————————
in the ———————————————————————— part of this work.

Signed ————————————
 Artist

Name ————————————————————————————
Address ————————————————————————————
Telephone ————————————————————————————

ART ORGANIZATIONS

There are hundreds of art organizations all over the country and it is impossible to list them all. We have selected a broad cross section of them according to the services offered.

The choice of organizations is totally arbitrary and is not meant to indicate that they are more or less responsible than any others. However, the authors do have some direct experience with all the groups listed. The resources listing following this section gives addresses for guides listing more art organizations.

Your local Arts Council may be able to put you in touch with local art organizations if you have a specific problem not covered by any in this list.

Artists Equity Association, Inc.

Formed in 1948, Artists Equity has grown to be a nationwide organization with headquarters in Washington, D.C., and branches in most states.

Members are accepted from all disciplines in the visual arts. Professionalism, educational background, past and present art activity commitment and exhibitions are among the factors considered before accepting an artist into the organization. There is a membership fee, which varies from branch to branch.

Chief means of contact between the national office and AEA members is through a newsletter.

A lobbyist in Washington keeps members in touch with any changes in the law or alterations in policy in the federal agencies.

The AEA is very active in fighting for artists' rights and they are actively pursuing the following issues:

1. Fair business practices with art dealers. Proof of insur-

ance coverage for artists, as well as a copy of the sales invoice, with prompt payment of any monies owed.
2. Freedom of expression.
3. Guidelines for all juried exhibitions.
4. Clear documentation of all artworks, whether multiples or unique.
5. Having 1 percent of the total costs of all new major construction work set aside for the purchase of art.
6. Representation by artists on the boards of art institutions.
7. Expansion of media coverage of artists.
8. Restoration of tax deductions for artists' gifts to a charity or museum.
9. Fair estate-tax policies for artists.

If you have any problems getting in touch with your local branch of Artists Equity, write directly to Artists Equity Association, Inc., 3726 Albemarle Street, N.W., Washington, D.C. 20016. Telephone (202) 244-0209.

Artists for Economic Action

As its name implies, the AFEA is concerned with improving the financial position of all artists. Although based on the West Coast, the organization has members all over the United States, who are kept in touch with developments through a newsletter.

The AFEA is dedicated to—
1. Furthering the economic, social and cultural status of the visual artist.
2. Educating the community at large in the recognition of the artist's contribution to society.
3. Promoting understanding and appreciation of the visual arts.
4. Encouraging collection and utilization of artworks in all areas of life.

5. Maintaining an emergency fund to assist artists in a crisis.

There is a membership fee. Those wishing to join the AFEA should write to Artists for Economic Action, 10930 Le Conte Avenue, Los Angeles, California 90024.

Business Committee for the Arts
This group is supported by donation from companies supporting the arts. They once supported primarily the performing arts, but have now moved into the visual arts.

The BCA presents art exhibitions, gives scholarships, institutes corporate grants and helps raise funds in special circumstances.

The BCA can be contacted at Business Committee for the Arts, 1706 Broadway, New York, New York 10019.

Bay Area Lawyers for the Arts
BALA was founded in 1974 and is modeled on similar organizations already in existence (one of which is the Volunteer Lawyers for the Arts, 36 West 44th Street, New York, New York 10036). BALA provides legal help and referral for artists, performers, writers and art organizations on the West Coast. It has related programs of education, publishing and research on arts law.

Any individual or organization with an art-related legal problem may apply to BALA for help by writing, calling or visiting the office.

Among other things, the BALA—
1. Provides free legal help and referral for indigent artists.
2. Sponsors education programs such as workshops and lectures.
3. Publishes a series of law guides and handbooks which are available at a small charge.
4. Sends a newsletter to all members.

5. Gives a 10 percent discount to members on most services offered by the BALA.

Membership fees vary according to your income. The BALA can be contacted at Bay Area Lawyers for the Arts, 25 Taylor Street, San Francisco, California 94102. Telephone (415) 775-7200.

Opportunity Resources for the Arts

The ORA offers employment assistance to other non-profit organizations in the arts. ORA helps develop job descriptions and staffing structures, consults on salary trends and conducts searches to fill positions.

ORA maintains a registry of people looking for positions with non-profit art groups. They welcome resumes from people seeking work in art-related fields. If they feel they can help, they will send a registration form. The annual fee on acceptance is fifteen dollars.

To submit resumes, or for more information, contact Opportunity Resources for the Arts, 165 West 46th Street, New York, New York 10036.

Change Inc.

For artists in emergency situations—about to be evicted, have the utilities shut off or any other imminent catastrophe —Change Inc. may be able to help.

The organization's sole function is to help artists in distress with grants ranging from one hundred to five hundred dollars. A decision can be made on an application within forty-eight hours.

The grants are non-repayable and no strings are attached, although, if your lot improves, you might feel inclined to make a donation.

Write or telephone Change Inc., Box 705, Cooper Station, New York, New York 10003. Telephone (212) 473-3742.

Artist Information Centers

There are a few centers in major cities supp
by a foundation or by the local Arts Council. They can pro-
vide information such as an alphabetical listing of the area's
artists, duplicate slides, brochures, grants, fellowships, scholar-
ship sources, upcoming open exhibitions, spaces and facilities,
available apprenticeships, nationwide organizations, buildings
still in the planning stages, shipping and insurance informa-
tion and current art-related legislation.

RESOURCES

Listed below is a selection of publications and addresses of organizations that may be of use to the artist.

Arts, General Subjects

The American Art Directory, edited by Jacques Cathell Press, American Federation of Arts, New York.

Artists Market, The Writers Digest, Cincinnati, Ohio.

Fine Arts Market Place, by Paul Cummings, New York, R. R. Bowker Co.

International Directory of the Arts, Berlin, Deutsche Zentraldruckerei.

Who's Who in American Art, New York, R. R. Bowker Co.

Alternative Gallery Spaces

Los Angeles: Los Angeles Institute of Contemporary Art (LAICA)
Some Serious Business

San Francisco: 80 Langton St.
La Manelle

Portland: Portland Center For the Visual Arts
Northwest Artists Workshop

Chicago: N.A.M.E. Gallery

Minneapolis: Artists' Exhibition Program

New York State: Institute for Art and Urban Resources
Committee for the Visual Arts
The Kitchen Center for Video and Music
A.I.R.
Artpark at Lewiston
Exhibition sites, Clocktower, 108 Leonard St.
P.S.I. in Long Island City, which also supplies studio spaces.

Copyright

To register a claim for copyright write to Register of Copyrights, Library of Congress, Washington, D.C. 20559.

Framing and Conservation

How to Care for Works of Art on Paper, by Francis W. Dolloff and Roy L. Perkinson, (Boston: Museum of Fine Arts, 1971).

A Handbook on the Care of Paintings, by Caroline K. Keck, (New York: Watson-Guptill, 1965).

Grants

The National Directory of Grants and Aid to Individuals in the Arts, by Daniel Hillsaps and Editors of WIAL (Wash. Intl. Arts)

Job Placement

College Art Association (write for local address), 16 East 52nd Street, New York, New York 10022.

Arts Inc., Box 32382, Washington, D.C. 20007.

Women's Caucus, Placement, Meredith Johnson, 362 Broadway, New York, New York 10013.

Museums

A Guide to Art Museums in the United States, by Erwin O. Christensen.

Periodicals

American Artist Business Newsletter, 2160 Patterson Street, Cincinnati, Ohio 45214. (10 issues, $25.)

Museum News/Museum Directory, edited by the American Association of Museums, 2333 Wisconsin Avenue, N.W., Washington, D.C. 20007. Telephone (202) 338-5300.

Resale Number

Get in touch with your local State Board of Equalization.

Tax

To appeal an IRS decision about declaration of business or hobby, contact your local county courthouse or city hall. Ask for Publication #556, Audit of Returns, Appeal Rights and Claims for Refund.

Legal Guide for the Visual Arts, by Tad Crawford (New York: Hawthorn Books, 1977).

Tax Information on Accounting Periods & Methods, IRS Publication 538.

Tax Guide for Small Businesses, IRS Publication 334.

The Tax Reliever, a guide for the artist by Richard Helleloid (St. Paul: Drum Books, 1979).

FRAMING AND CONSERVATION

Old and contemporary masters are generally expensively framed in a style that probably would not suit a lot of work and is also well out of the reach of most artists' pockets.

Work by modern professionals is usually simply framed but with the highest quality materials. It is always worth spending time and thought on the frame so that the finished product is well proportioned and complements rather than overpowers your work.

The following suggestions will help in displaying works on paper, including photographs, which should need little restoration over the years.

1. Most works of art on paper need to be matted. The mat protects the picture from contact with the glass. Without the mat, the glass can stick to the picture and moisture can condense on the glass causing mold growth and staining. Keep your image surface away from the glass or plastic.

2. Mat board should be 100 percent rag composition. In the case of works of art which are not meant to be matted, rag board strips can be inserted to provide spacing between the image and the frame.

3. Mat can be hinged to backboards with gummed white cloth tape. Do not use pressure-sensitive tape.

4. Works of art are hinged into their mats at the top edge only, using paper hinges and water-soluble paste. Works should never be dry-mounted or adhered all over to their backboard; paper expands and contracts with the moisture in the air, which would cause buckling and tearing of the paper.

5. If a picture needs to be rematted the hinges can simply be cut at their fold and new hinges glued over the old.

6. The mat should be cut to be slightly larger at the bottom than at the sides or top. This is restful for the eye and makes a less demanding border for the work.

7. The frame chosen should be sturdy and preferably easy to open in order to switch works of the same size for

different exhibitions. One popular type of frame material is natural light waxed wood. It is inexpensive and effectively used by many museums.

8. Select glass or plastic to cover the work but never use plastic with pastel, charcoal or loosely bound media for they will cling to the plastic surface.

9. If all-rag board cannot be used throughout the frame, sheets of acid-free paper can be inserted to set up a barricade to acid migration. Brass-plated pins, which will not rust, should be used.

10. When attaching multi-strand wire to the back of the frame for hanging, make sure that the screw eyes are well placed and of the right thickness to support the weight.

11. Bumper guards of rubber, cork or felt are placed on the bottom back corners, not to protect the wall, but to allow air to circulate behind the picture thus preventing moisture condensation and mold growth.

12. Works on paper should be kept out of direct sunlight or even strong artificial light. Optimum conditions are a relative humidity of 50 percent and temperature of 70° or below.

13. Care should be taken so that the area is as free from dust and pests as possible.

Here are further suggestions for framing paintings.

1. Make sure the frame fits the painting and is neither too large or too small. The frame should set level against a flat surface. Warpage will force the fabric to buckle which will cause loss of paint layers. The depth of the frame should extend beyond the stretcher to provide a brace against the wall.

2. Do not use nails to attach the stretcher to the frame. The vibration caused by driving the nail in will crack the paint, and nails can split the wood. Use metal mending plates instead, which screw in two places to the frame and are bent to hold the stretcher in place by pressure. Several plates need to be used on all four sides.

3. Cover the back of the picture with formecor or card-

board to provide a rigid barrier to damage from the back. This is especially important during transportation.

4. Check that your screw eyes, multi-strand wire and wall nails or hooks are secure and strong enough to hold the weight of the work. Try to use a hanging device that allows the picture to lie flush with the wall. If not, don't put so much hanging wire on the work that it shows above the frame, and don't leave a bundle of wire behind the picture where it might poke or wear through the fabric.

If there is damage done to a work of art that you cannot repair yourself then you should use your exact list of all materials used and take the work to a qualified conservator. Most museums in large cities will have a conservator on the staff or will be able to recommend one.

ART-RELATED JOBS

For those artists who are still in shool, remember to consider the possibilities of graduate school. It remains one of the cheapest methods to produce your work without having to accept any of the responsibilities of the gallery world.

Almost all schools have some form of Career Development Center which acts as a central resource agency for art-related jobs. You can be put on a registry very easily and a simple telephone call will supply you with any new listings.

The services of such centers seem to be reciprocal from school to school, so if you move away or back home, you might be able to register with an associated organization. This service also supplies letters of recommendation which they will keep on file for you for graduate school or a professional job.

Many art schools are members of the College Art Association, which holds a convention once a year and issues a newsletter which lists job vacancies, primarily in the teaching profession.

Other organizations which have newsletters with job listings are the American Association of Museums, Arts Inc., and the Opportunity Resources for the Arts, which is a New York-based non-profit organization. Addresses and further information are given under "Art Organizations" and "Resources" here in the Appendix.

As with registries, you must be careful that the organization is not just one to collect a fee and then not deliver the goods. Most newsletters do charge some sort of subscription but check to find out which are reputable.

There are books available that list names and addresses of art-related establishments. Some are directories of artists, schools, museums and grants while others list marketplaces. Most can be found in a good public library. Selected names and addresses of some of them are listed under "Resources" in this Appendix.

Art-related employment can be broken down into two categories: work in an art-related business, and work in a field that frequently uses the services of artists.

Examples of the first category are art dealers, galleries, art suppliers, graphics, greeting cards and textile companies, jewelers and schools and colleges.

Examples in the second category are publishing, advertising, public relations, retail businesses, museums, libraries, magazines, newspapers and art therapy.

Museum and gallery exhibition is an area which still needs people. A few universities are starting to offer MFA and MA degrees in this field.

Teaching art has become almost inaccessible as a career for artists because of the dropping enrollment, and the tenured positions, which both lessen demand for teachers at all levels of education.

If you are working full time as a teacher, it is a very demanding occupation. You have to devote a great deal of time to your students. A teacher's own artwork, even with the three months' vacation, suffers and leaves him very little opportunity to build up a full body of representative pieces. Charlie Simonds, after many years of full-time teaching, was very well respected by faculty and teachers alike. However, it wasn't until he decided to leave teaching and concentrate on his art that he was able to produce work of real depth. After years of trying, he has now broken into the galleries in New York and California.

Don't forget your local newspapers for job listings, as well as bulletin boards in art departments, museums and co-ops. Professionalism in application for these jobs is just as important as when you seek a showing place.

You can, of course, favor non-art-related jobs, which will support you so that you will have more creative energy left for the making of art.